BEGINNER'S GUIDE

to Adobe®
Photoshop®

Third Edition

MICHELLE PERKINS

AMHERST MEDIA, INC. ■ BUFFALO, NY

Thanks to Barbara, Carey, and Chuck for proofreading—and to all those whose images appear in the book.

For Ron—
La joie de vivre c'est dans les belles chansons.

Published by:
Amherst Media, Inc.
P.O. Box 586
Buffalo, N.Y. 14226
Fax: 716-874-4508
www.AmherstMedia.com

Publisher: Craig Alesse
Assistant Editor: Barbara A. Lynch-Johnt

ISBN: 1-58428-187-1
Library of Congress Card Catalog Number: 2005937369

Printed in Korea.
10 9 8 7 6 5 4 3 2 1

TABLE OF CONTENTS

CHAPTER ONE

Getting Started

In this chapter, you'll learn the basic terms and techniques you need to begin using Photoshop successfully. Armed with this information, you'll be ready to make critical decisions about opening, saving, and using your image files.

INTRODUCTION

Whether you long to be the next Ansel Adams or just want to make your snapshots look their best, Photoshop offers powerful tools for making the most of your images.

Let's admit it. We've all taken pictures and thought, "If only . . ."—if only Mom's eyes weren't closed, if only that wallpaper wasn't in the background, etc. With Photoshop (and a little artistic ability) you'll never need to live with these problems again—and the fixes often take only a few seconds.

Who Should Read This Book
This book is designed for readers who have little or no previous

experience with Adobe® Photoshop®. It teaches the basic skills needed to design attractive images for use in print, on the Internet, or in any other application you can imagine.

What You Need to Know
While you need no previous knowledge of Photoshop to use this book, it is assumed that you have the basic skills needed to use your computer. You

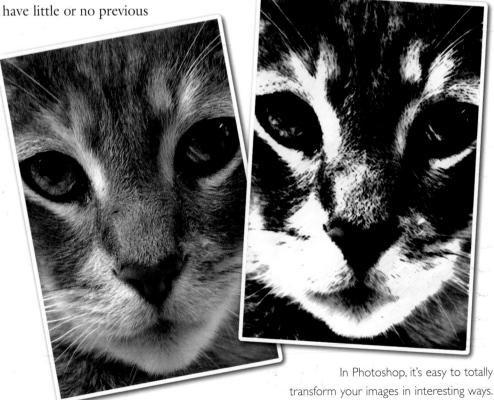

In Photoshop, it's easy to totally transform your images in interesting ways.

TERMS TO KNOW

Color Mode—The term for the set of colors that are combined in various amounts to create all the other colors in your image.

Compression—A system of arranging image data more efficiently (or removing data that is deemed extraneous) in order to reduce the file size.

File Format—The "language" in which the digital image is written. Tells an application how it should handle the data in the file to display it correctly.

File Size—The amount of memory required to store and/or process an image. The larger the file size, the more space required to store it and the more time required to perform operations on it.

Pixel—The smallest discrete part of a digital image.

Resolution—How close together the pixels (dots) in an image are. Expressed as dpi (dots per inch).

should know how to: save and name files, open files, print, etc. Since clear, step-by-step information on installing Photoshop is provided with the software itself, you are advised to follow those instructions carefully (noting the system requirements listed on the software) and install Photoshop on your computer before beginning the lessons in this book.

Version of Photoshop

This book is specifically tailored for users of Photoshop CS2, but much of the material will also apply to readers who wish to use earlier versions of the software. While most of Photoshop's basic tools and functions have remained the same since version 7.0, they have been upgraded, supplemented, and to some degree relocated in CS2.

Using This Book

To try out the techniques in this book, you will need one or more digital images to use as "test subjects." You will be best off using a photographic image. You can use images from a clip art col-

lection, an image you have scanned yourself, or a shot from your digital camera.

For many sections of this book, the sample images are available as low-resolution files for download from the publisher's web site. To access these, visit <www.AmherstMedia.com/downloads.htm>. Click on the title of this book and enter the password P1823. Be sure to read the important notes that accompany the images as a PDF file. (Most computers come with Adobe® Acrobat®, the software needed to open this type of file. If you do not have this program, you can download it for free at www.adobe.com.) The notes in this file explain some settings that you'll need to adjust in order to use these images, which are low-resolution, instead of the high-resolution versions used in the preparation of the lessons.

ALL ABOUT RESOLUTION

Resolution is one of the concepts that people who are new to digital imaging usually find the most confusing. Fortunately, it's not as tricky as it might initially seem to be.

Digital images are made up of dots called pixels. The resolution of an image tells us how close together those dots are (the dots per inch—referred to as the "dpi" of an image). Images with dots that are close together are said to have a "high" resolution (a high number of dots per inch). Images with dots that are far apart are said to have a "low" resolution.

The resolution of an image, to a great degree, determines the apparent quality of the image. High-resolution images tend to look clear and sharp—more like photographs. Low-resolution images tend to look grainy, speckled, and blurry. Does this mean you should always create the highest-resolution image you can? Well, no. The more dots in an image, the more the computer has to remember and move around every time you ask it to do something with those dots. This means it will take longer for the image to open, and performing operations on it will be slower. Because it is bigger, you'll also need more space on your hard drive to store each high-resolution image.

Which Resolution is Right?

So what should the resolution be? The answer is: only as high as it has to be.

WHICH IS BIGGER?

Which is bigger, the image on the left or the one on the right? Actually, it all depends on how you look at it. The image on the right definitely covers more space, but both images are made up of the same number of identical dots. In the image on the left, the dots are tightly packed, giving it a high resolution (a high number of dots per inch). In the image on the right, the dots are far apart, giving it a low resolution (low number of dots per inch). In the digital world, how much "space" an image covers makes very little difference. What counts is how many dots (pixels) it is made of. How many pixels your image should have is determined by what you want to do with it.

The resolution your image needs to be depends on how you want to use it. The image on the left is at 300dpi, perfect for printing in a book. The image on the right is at 72dpi. This would look just fine on a web site, but its resolution is too low to look good in print.

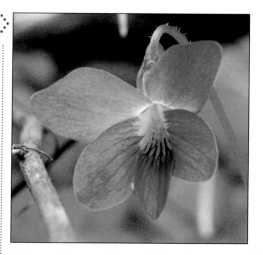

The precise number will be determined by what you want to do with the image.

If you want to use it on your web page, you'll select a relatively low resolution—probably 72dpi. This is all that is needed to create an acceptably sharp, clear image on a monitor. Anything more wouldn't make the image look any better and would increase the time the image takes to load.

If you want to generate a photo-quality print on your inkjet printer, you may want to create a file as large as 700dpi. Check the manual that came with your printer for the resolution it recommends for various print settings.

If you'll be having someone else (like a photo lab) print your image, ask them what they recommend.

Changing Resolution

Photoshop will allow you to change the resolution of an image. As nice as this sounds, though, this doesn't take the place of proper planning.

Photoshop is great at moving around existing dots (making them closer together or farther apart) and is even pretty skilled at removing dots (reducing resolution). What it doesn't do well

is allow you to turn 50 dots into 500 dots. If you ask it to do this, the program will have to guess where to put these dots and what they should look like. Invariably, it won't guess 100 percent successfully, and your resulting image will appear blurry.

In a pinch, you might be able to get away with increasing the resolution by 25 percent—but any more than this and you'll probably not like the results.

Don't Just Guess

If you're not sure what resolution you need to create the product you have in mind, find out *before* you create your file. There's no point in wasting your time to make complicated refinements on an image that turns out to be unusable. If you'll be using your image in multiple applications (say you want to make a print but also plan to e-mail the photo to someone), create your image at the largest size you'll need. Make any needed corrections to this large file, then reduce its size and save multiple copies of the image for other uses.

DIGITAL COLOR MODES

When we shoot images on film, we tend to take color for granted and leave it up to the folks at the lab. With digital, we have to know a little bit more to really make our images shine.

If you ever took an art class, you probably know that combining two or more colors creates new colors. For example, combining blue paint and yellow paint makes green paint. In fact, almost all colors are combinations of some other colors. The exceptions (the colors you can't create by combining others) are called primary colors. In digital imaging, the set of primary colors that are used to create all the other colors in your image is called the color mode. In this section we'll take a basic look at color modes. For more detailed information on color in photographic images, see chapters 4 and 5.

Why It Is Important

The way that the colors are created in an image can be important for reducing the file size of the image (perhaps to make sure it loads quickly on your web page) or improving print output. A few common applications and their suggested color modes are noted in the list on the facing page. You may find other reasons to pick one mode over another.

In this book, we will be working almost exclusively in the RGB mode. It is the easiest to learn and offers the most options (most Photoshop features work in other color modes, but all work in

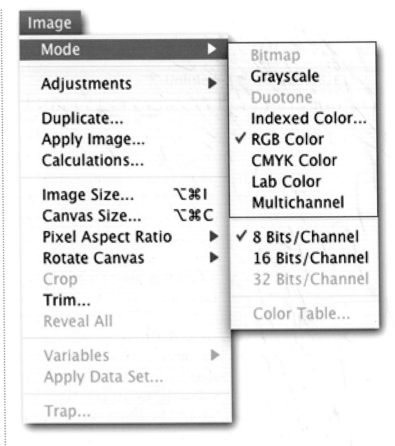

RGB). Depending on how you want to use your images later, you can convert the finished versions to another mode. To change the color mode of an image, go to Image>Mode and select the desired color mode from the list.

RGB Mode

If your image is in the RGB mode (the most commonly used mode in Photo-

To switch between color modes, just go to Image>Mode and select the desired mode from the pull-down menu.

BASIC COLOR MODES AND USES

RGB—Images to be viewed on a screen (such as those used on a web page or to be e-mailed to friends); images you are still working on (works in progress); images you plan to print at home or at a photo lab.

CMYK—Images that will be printed on an offset press or using other professional processes.

Indexed Color—Images that need to load quickly (such as on a web page) and where perfect color reproduction is only a secondary concern.

shop), then all of the colors in that image are made up of some combination of red (R), green (G), and blue (B). It may be hard to believe, but by combining just those three colors in slightly different amounts, you can create millions of colors. As a result, this is the best mode for working with color images that you really want to look their best. This is the mode normally used for on-screen viewing (like on the Internet) and most photographic printing (like on an inkjet printer or at a photo lab).

Grayscale Mode

Another common color mode used in Photoshop is Grayscale. As you might imagine from the name, all of the colors (well, *tones*, to be more accurate) in this mode are actually shades of gray—exactly like a black & white photograph. In

To instantly convert a color image to a black & white one, go to Image>Mode>Grayscale to change to the Grayscale mode.

fact, to quickly convert a color image to a black & white one, you can just switch your image to the Grayscale mode by going to Image>Mode>Grayscale.

Indexed Color Mode

This color mode is used for images to be viewed on-screen. It is most useful in situations where perfect image quality is of secondary concern when compared to load time (how long it takes the image to appear on-screen). By limiting the total number of colors in the image to a few hundred (as compared with the millions of colors in RGB), you can get a pretty good-looking image that won't keep viewers of your web site waiting around for your images to load.

Bitmap Mode

This mode uses only black and white pixels (no grays). It's more useful for line art than photos, but it can create some interesting effects. To convert to the Bitmap mode, your image must first be in the Grayscale mode.

CMYK Mode

The CMYK mode is used for professional printing, like in books and magazines. If you need your final image to be in this mode, it's best to make all of your adjustments and enhancements in RGB, then convert to CMYK as the last step.

IMAGE FILE FORMATS

They may not seem like much, but those three little letters after the dot in the file name actually tell you a lot about an image. Better yet, they tell other programs how to work with the data in your file.

Think of the file format as the language in which an image is written. It tells applications, like word processing software or web browsers, that your file is a picture (rather than a text file, for example) and how it should handle the data to display it correctly. The file format is indicated by a tag (.TIFF, .JPEG, etc.) after the file name.

Compatibility

If you travel to France and try to speak Portuguese to the natives, you'll likely encounter some problems. The same thing can happen with some software applications when you ask them to work with a digital file that doesn't speak their language. Photoshop is very multilingual; it "speaks" a wide variety of file formats. Other programs aren't as well educated—many recognize only one or two file formats. If you plan to use your digital image in a program other than Photoshop, read the software's manual to determine what formats it accepts, then save your image accordingly.

Compression

Some file formats give you the option of reducing the amount of memory your computer will need to store an image. This is called compression.

Photoshop
BMP
CompuServe GIF
Photoshop EPS
JPEG
Large Document Format
PCX
Photoshop PDF
Photoshop 2.0
Photoshop Raw
PICT File
PICT Resource
Pixar
PNG
Portable Bit Map
Scitex CT
Targa
✓ TIFF
Photoshop DCS 1.0
Photoshop DCS 2.0

Photoshop is able to read and write a wide variety of file formats.

By reducing the amount of memory required to store an image (i.e., the file size), compression allows more images to be stored in a smaller space and lets them be transmitted over the Internet more quickly. Sound too good to be true? It is (mostly). Imagine you crush a soda can. It *will* take up less space, but it will also never *look* like it did to begin with. With digital compression, the

When an image is enlarged, you can really start to see the difference in quality between JPEG compression (left) and LZW (right).

same idea applies—of course, it's more sophisticated, and your images won't look nearly as bad as your soda can.

When an image is compressed, equations are applied to arrange the data more efficiently or to remove data that is deemed extraneous. As a result, your image won't look as good. But, the loss in quality may not be objectionable—or it may be worth it to make an image load more quickly on your web page.

Two file formats that offer compression are JPEG and TIFF. JPEG offers "lossy" compression, meaning that it removes data and significantly degrades the image. Fortunately, a slider in the

JPEG Options window lets you control the degree of compression, so you can compress the file just a little (for better image quality) or a whole lot (when quality isn't as important).

The characteristic grid pattern created by JPEG compression (see above) becomes especially apparent when an image is saved and resaved, compressing it each time. For works in progress, this is not a good file format, but it's standard on the Internet because of the small file sizes it produces.

TIFF offers "lossless" compression called LZW, which doesn't throw anything out (so the image quality remains better), but it also can't compress the image as much.

You can also select ZIP compression from the TIFF Options window. This is similar to LZW, but it adds a layer of protection that helps reduce the likelihood of corruption when files are sent across the Internet.

In the TIFF Options window (right), you can select no compression, LZW, ZIP, or JPEG compression. In the JPEG Options window (far right), you use the slider at the top of the box to strike the desired balance between file size and image quality. As the file size decreases, so does the image quality.

TIFF Options

Image Compression
- ◉ NONE
- ○ LZW
- ○ ZIP
- ○ JPEG

Quality: [] Maximum ⏷
small file large file

OK
Cancel

Pixel Order
- ◉ Interleaved (RGBRGB)
- ○ Per Channel (RRGGBB)

Byte Order
- ◉ IBM PC
- ○ Macintosh

☐ Save Image Pyramid
☐ Save Transparency

Layer Compression
- ○ RLE (faster saves, bigger files)
- ○ ZIP (slower saves, smaller files)
- ○ Discard Layers and Save a Copy

JPEG Options

Matte: None ⏷

OK
Cancel
☑ Preview

Image Options
Quality: [12] Maximum ⏷
small file large file

Format Options
- ○ Baseline ("Standard")
- ◉ Baseline Optimized
- ○ Progressive
Scans: [3] ⏷

Size
~14.39K / 2.54s @ [56.6Kbps ⏷]

The Basics

Before you get started making alterations to your images, there are a few more things to learn—like how to view images on-screen for the best results and how to undo any mistakes you might make.

THE WORK AREA

The following is a brief tour that will familiarize you with the landscape of the software. We'll be coming back to all of these features over the course of this book.

The work area in Photoshop might initially seem a little bit cluttered and overwhelming—there are a *lot* of menus and boxes! However, the workspace tends to combine similar items into related groupings. This makes navigating it much easier.

Menu Bar

The Menu bar runs across the very top of the screen and contains a number of pull-down menus. The following is a brief overview:

File—Open, Close, Browse, Import files, and more.
Edit—Step Forward/Backward, Copy/Paste, and more.
Image—Rotate, resize, crop, and make other image adjustments.
Layer—Create, eliminate, or refine layers.

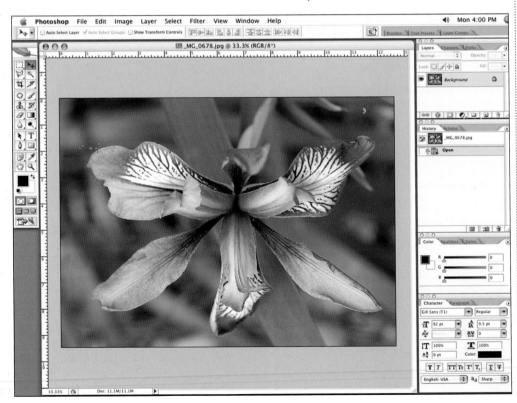

The Photoshop work area has many palettes, menus, and windows to work with.

Photoshop Toolbox

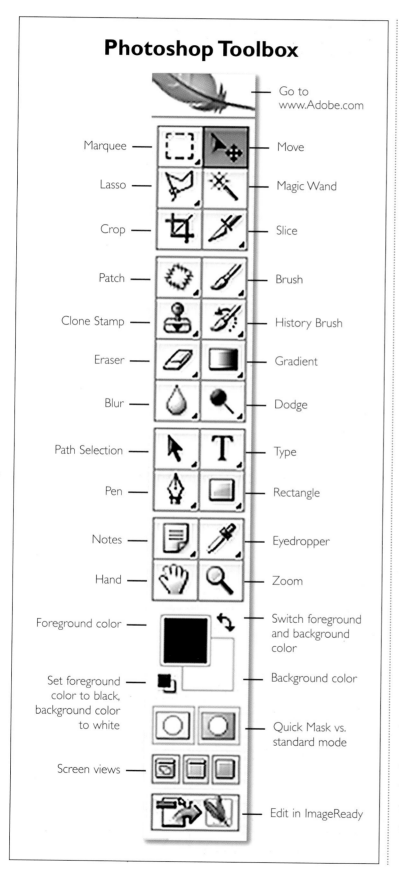

Go to www.Adobe.com

Marquee — Move
Lasso — Magic Wand
Crop — Slice
Patch — Brush
Clone Stamp — History Brush
Eraser — Gradient
Blur — Dodge
Path Selection — Type
Pen — Rectangle
Notes — Eyedropper
Hand — Zoom
Foreground color — Switch foreground and background color
Set foreground color to black, background color to white — Background color
Quick Mask vs. standard mode
Screen views
Edit in ImageReady

Select—Create, eliminate, or refine selections (see chapter 8).

Filter—Select and apply special effects to your image, including artistic looks, sharpening, distortions, and more.

View—Control the visibility of rules, guides, screen views, and more.

Window—Open and close the various palettes (see pages 16–17).

Help—Access to the various help features to rescue you when you're totally stuck (see pages 26–27).

Palette Well

At the far-right side of the screen is the Palette Well. For more on this, see pages 16–17.

Options Bar

Beneath the Menu bar is the Options bar. This bar changes depending on which tool is selected, allowing you to customize the function of that tool to your liking.

Palettes

Free-floating palettes will, by default, be open on the right side of the screen. To customize the available palettes and their locations, see pages 16–17.

Toolbox

At the far left of the screen is the Toolbox. This contains all of the tools you'll need to refine your images—like the Crop tool, Brush tool, Clone Stamp tool, Marquee tool, and more. These will be covered in greater detail later in the book, but to the left is an overview that you may wish to refer back to.

OPENING IMAGES

When you start taking digital photos, you'll probably notice that you take more images than ever—and that can mean trouble when it comes to finding any given one. Photoshop can help!

When it comes to opening images in Photoshop, you have three basic options: create a new image, open an existing image directly, or browse your images using Bridge.

New Image

If you want to create a photo montage or some other art project where you need to start with a blank canvas, you'll want to create a new image. To do this, go to File>New. In the dialog box that appears, set the size of the image and the resolution as you like using the pull-down menus and fields in the Preset field. You can also name your new image at the top of the window and select the background color at the bottom of the window. When you're done, hit OK.

Open an Image

If you know exactly what image you want to open and where it is stored, you can just go to File>Open and locate the image file in the dialog box that appears.

Bridge

When it comes to tracking down and opening images, one of the most helpful features in Photoshop isn't actually *in* Photoshop; it's a standalone application that comes with Photoshop and is launched by going to File>Browse in Photoshop. Once this application is open, it can run in the background so it's always ready and waiting when you want to flip back to it to find another file. Basically, Bridge gives you a way to organize and preview your images in a snap.

When you launch Bridge, a full-screen window appears. At the top left, you'll see a navigation pane with tabs for Folders and Favorites. Once you've picked a location/folder from this pane, all of the images in that spot will appear as thumbnails in the large pane that takes up the right-hand two-thirds of the Bridge window. Just click on a thumbnail to see a larger preview of the image in the middle pane on the left side of the window.

At the same time, information about this image (called metadata) will appear in the bottom-left pane. This information is recorded by your camera when you take a digital photo and includes data like the size and resolution of the

Using Bridge makes it easy to find your images.

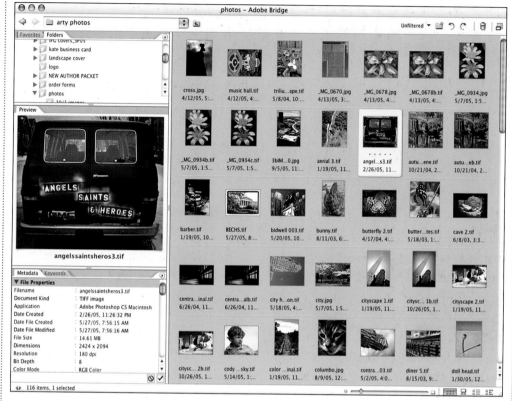

image, when it was taken, and (often) the camera settings used—like the aperture, shutter speed, and white balance.

In this same pane, you can also also flip to the keywords tab and enter terms that will make it easier to find your photos in the future. For instance, you could label all the photos of your trip to Paris. To do this, find the photos and go to Edit>Select All in Bridge. In the keywords tab, click on the New Keyword icon (at the bottom right of the pane) and enter "Paris Trip 2006." Next time you want to find your Paris photos, just click on the new keyword in Bridge! (*Note:* Of course this only works with images your computer has access to at the time. If you keyword-label images on a CD and eject the disc, Bridge won't be able to find the photos.)

You can also quickly rank your images using a star or color system. To do this, click once on any thumbnail in the large preview pane. Then, go to Label and select the label you want. Once you've labeled some images, go to the top-right corner of the Bridge window and click on the Unfiltered menu. From the menu, select one of the rankings you've applied to some images and those photos will appear. This is a great way to keep track of your favorite shots—just give them five-star rankings.

LEARNING FROM THE METADATA

If becoming a better photographer is something that's important to you, take a few moments after each shoot to evaluate your images. What worked? What didn't? Why not? When evaluating exposure, referring to the settings stored in the metadata can be a useful tool for spotting problems (in poor shots) and seeing how to fix them (in good ones).

WORKING WITH PALETTES

Photoshop may well have more palettes to manage than any other program you're accustomed to using— and their presence can be both a blessing and a curse.

Palettes are small windows that help you enhance your pictures by giving you information about your image or offering you options for modifying it. Photoshop offers almost twenty palettes that can be viewed in a number of different ways depending on your personal preference. It would be great to be able to have them all visible at once, but unless you work on a system with multiple monitors, this won't leave you much room to view your image.

The following information will make you familiar with the names and functions of the most-used palettes, and the options you have for organizing them.

As you work with Photoshop, you'll probably find that there are some palettes you use all the time and want displayed prominently. There will be others that you use so rarely that you can just call them up when you need them and then promptly put them away.

The Palettes

The individual palettes and their uses will be covered in detail later in the book as we encounter a need for each. For the meantime, however, a quick way to access any of the palettes is to go to the Window pull-down menu and select the palette you want to open from

Window	
Arrange	▶
Workspace	▶
Actions	⌥F9
Animation	
Brushes	F5
Channels	
✔ Character	
✔ Color	F6
Histogram	
✔ History	
Info	F8
Layer Comps	
✔ Layers	F7
Navigator	
✔ Options	
Paragraph	
Paths	
Styles	
Swatches	
Tool Presets	
✔ Tools	

You can open any palette by selecting it from the Window pull-down menu. You can also see which palettes are currently open by noting which ones have check marks.

the list (boxed above in red). This will make the palette appear on your screen. You can also see which palettes are currently open by noting which items in the Window menu are checked.

The Palette Well contains tabs for various palettes.

When you click on one of the tabs in the Palette Well, the corresponding palette drops down and is available for use.

The Palette Well

The Palette Well is located at the upper-right corner of the screen. It looks like a series of file folder tabs, each labeled with the name of a palette. To open a palette, just click on the appropriate file tab and the palette will drop down from it. The palette will automatically snap closed as soon as you click anywhere else on your screen.

In and Out of the Well

To move a palette out of the Palette Well, simply drag the tab out of the Well and onto the desktop. This will place the palette in a separate, free-floating window that will remain open on your desktop until you put it away.

Once you have a free-floating palette window on your desktop, you can drag other tabs into the same window to create a palette group. The names of the palettes in the group will appear at the top of the window as file tabs. As with the Palette Well, you can access the indi-

When you drag palette tabs out of the Palette Well, they appear in free-floating palette windows. You can drag more than one palette into each window to group the palettes as you like. Here, the Brushes and Color menus are in one window.

vidual palettes by simply clicking on a file tab.

To return a palette to the Palette Well, simply drag its tab out of the free-floating window and back into the Palette Well. You can also click and drag the tabs to move palettes from one palette group (free-floating window) to another.

Palette Options

Many palettes have a drop-down menu, denoted by a black arrow in a circle, at their upper-right corner. From this menu you can select additional options for the function of the palette and create custom settings. Since they vary from palette to palette, these options will be discussed later, as we look at the functions of the individual palettes.

VIEWING IMAGES

If you really want to be able to create professional-quality results, you need to learn to view your images well—getting very close so you can refine the tiniest details of the photograph.

A lot of the time, you'll be making corrections or changes to your image as a whole—like adjusting the overall color balance in the photo. In these cases, you'll want to see the whole thing from top to bottom and side to side to ensure your changes aren't having any negative effects on some part of the image you can't see at the moment.

There will be other times, however, when you'll want to change just a small part of the image—you might want to remove a small blemish on someone's face, for example. In cases like this, it will help you to be able to enlarge just that portion of the image on the screen so that you can see every detail clearly and work as precisely as possible.

There are several ways to control this. To try them out, open an image and practice getting different views of it.

Zoom

When you open Photoshop, the long vertical window at the upper-left corner of your screen is called the Toolbox. If this is not visible, go to Window>Tools to bring it up.

From the Toolbox, select (by clicking on it) the icon that looks like a magnifying glass (near the bottom-right corner). This is called the Zoom tool.

Position it over the area you want to zoom in on and click one or more times. To zoom out, hold down the Alt/Opt key (a little minus sign will appear on the magnifying glass) and click one or more times.

You can also click and drag over the area that you want to appear on your screen. If you click and drag over a small area of the image, it will be greatly enlarged to fill your screen. If you click and drag over a larger area, it will still jump to fill your screen, but it won't be as greatly enlarged. This is a handy way to get a careful look at an area where you want to make detailed refinements.

Percentage View

At the lower-left corner of your document window, you'll see the percentage view. You can type in any percentage that you like, enlarging or reducing your view of the document accordingly.

There are several ways to control your image view in Photoshop. As seen above, you can enter the percentage at which you want to view the image in the lower-left corner of the image window. The Toolbox, from which you can select the Zoom tool to magnify your image, is shown to the right.

At the top of the View menu, you'll find some options for controlling your image view. The Fit on Screen option is particularly helpful.

View Menu

At the top of the View menu (above) you'll also find several ways to control your image view. The most useful for beginners are: Zoom In, Zoom Out (like the Zoom tool), and Fit on Screen (a quick way to view your entire image). The Fit-on-Screen command is so useful, you may want to memorize the keyboard shortcut (shown to the right of the command in the menu).

Scrolling

Once you have zoomed in, you can use the scroll bars at the right and bottom of the screen to move across the image

and view individual areas at a higher magnification.

Navigator

To view the Navigator window, go to Window>Show Navigator. The percentage at the lower-left corner of this window indicates the current view (type over it to change this). You can also move the slider at the bottom to the right or left to change the size of the area that is being viewed. Similarly, clicking on the small-mountains icon zooms out, while clicking on the big-mountains icon zooms in. A red box indicates the area that is currently visible on the screen.

Once you have zoomed in to the desired enlargement, you can simply click and drag the red box over the area that you want to see displayed in your main window.

In the three sequential views of the image below, you can see how this works.

In the Navigator window (shown inset in the above images), the red box indicates the area of the image that is visible on-screen (left). When you zoom in, the visible area is reduced (center). You can click and drag on the red box to change the area of the image that is visible without changing its enlargement (right).

CORRECTING MISTAKES

If there's one thing about digital imaging that really stands out, it's how forgiving it is. When you mess up (and you will mess up), you can backtrack without having to start over from scratch.

Yes, you're going to make mistakes from time to time. You'll apply the wrong effect (or realize that the intended one makes the image look really bad). Here's what to do.

Edit>Step Backward

A quick and easy way to undo a recent mistake is to go to Edit>Step Backward. This undoes the last operation you performed on an image. It can be used multiple times in sequence to undo multiple steps. If you decide you actually *don't* want to undo the step, go to Edit>Step Forward (this can also be applied multiple times).

History

The Edit>Step Backward command can be used to undo one operation at a time. This is very helpful, but what if you realize that your image got off track a *long* time ago? Or what if you just want to compare your enhanced image with the original? Having to hit Edit> Step Backward fifty times would be pretty annoying! Instead, you can use the History palette.

The History palette records each change you make to an image. This includes any action that affects the pixels in the image, so it does not include things like zooming in and out, moving palettes around on your screen, etc. It does, however, include each individual brush stroke you might use, and just about anything else you can do to an image. If the History palette is not visible on your desktop, go to Window> History.

In its default setting, the History palette will record only the most recent twenty states (the term for the individual entries in the list of steps in the palette). This helps to save memory, but you can set the number of saved states higher by going to Photoshop>Preferences>General (Mac) or Edit>Preferences>General (Windows).

If you want to keep a particular state throughout your editing session, acti-

TRY IT OUT

The example shown on the facing page uses tools that we'll be getting to shortly, but you can try out the History palette without them. Open an image (see pages 14–15) and go to Filter> Artistic>Watercolor. Then, hit OK in the window that appears. Next, take a look at the History palette. You'll see a new state called Watercolor under the state labeled Open. Clicking on the Open state will undo the Watercolor filter; clicking back on the Watercolor state will redo it.

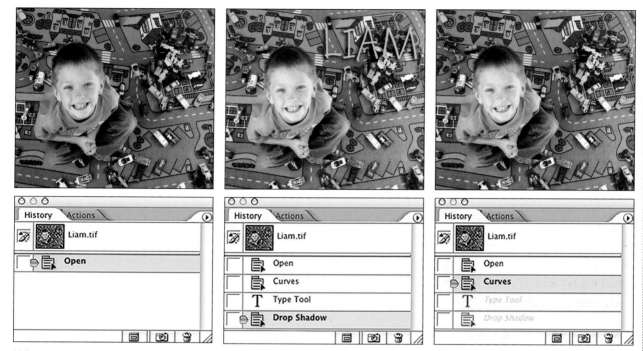

When an image is opened (top left), the History palette shows this operation ("Open") as the first state (bottom left). As changes are eventually made to an image, you can track them from top to bottom through the History palette (bottom center). In the image shown here, the Curves command was used to correct the exposure, then the Type tool was applied to the image, and a special effect (called a drop shadow) was applied. The resulting image (top center) was okay, but I wanted to see it again without the type on it. To do this, I simply clicked on the history state above the Type-tool state (right bottom). This cleared the type and the drop shadow (top right). I could begin working from here and automatically delete all the following states, or return to any other state and continue working from that point.

vate it in the History palette, then click on the camera icon at the bottom of the palette. This creates a snapshot that will appear at the top of the palette right under your original image. If you like, you can create multiple snapshots as you work on your image.

In the History palette, states are listed from the top down, so the oldest state of the image is at the top of the list, and the newest one is at the bottom. Each state is listed with the name of the tool or command used to create it, so you can navigate back through the history of an image pretty easily when you need to backtrack.

By clicking on the individual states in this timeline, you can move back and forth through the history of the image and easily compare previous versions to the current one, or undo the last ten steps with one click of your mouse.

When you select a state, you'll see that the ones below it dim. This indicates that if you continue working from the selected state, these later states will be discarded. Similarly, deleting a state (by dragging it into the trash can at the bottom of the palette) will discard all the states that came after it.

Important Note: When you close an image, all of the saved states and snapshots will be deleted, so be sure you're done with them before you close the image!

CHANGING IMAGE SIZE

Making an 8x10-inch print? A 4x6-inch print? A T-shirt? A greeting card? All of the above? In most cases, you'll want to adjust the size of your image to suit your final purposes for it.

More often than not, your image won't be exactly the size you want it for your print (or greeting card, or T-shirt, or web site, etc.). In these cases, you'll need to change the image size. If your image will be used in several ways, you may need to resize a few times to get the assortment of sizes you need.

Whenever you resize, remember to work from your largest needed file to your smallest. As noted on pages 6–7, Photoshop does a much better job at removing pixels than adding them, so this will help to ensure that your image quality remains as high as possible.

Image Size

Going to Image>Image Size lets you enter a width, height, and resolution for your image.

The Image menu contains options for resizing your photographs.

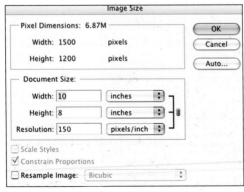

The Image Size window.

At the bottom of the Image Size window, you'll see two very important boxes. This first is the Constrain Proportions box. When this is checked, the original relationship between the height and width of the image will be retained. Unless you intend to distort your photograph, you should always keep this box checked.

The Resample Image box lets you tell Photoshop whether you want it to

change the total number of pixels in your image. If this box *is not* checked, reducing the height and width of your image will increase the resolution (the existing pixels will be condensed into a smaller area). If this box *is* checked, reducing the height and width of your image will not change the resolution (the total number of pixels will be reduced to suit the smaller area).

Canvas Size

Going to Image>Canvas Size lets you enter additional height and/or width around your image. The color of this extra space will be determined by the background color (see pages 100–101).

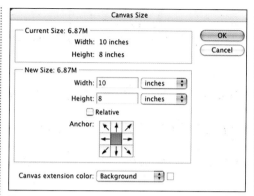

The Canvas Size window.

This is a good way to create extra space around a photograph. You can then use the space to add text or other elements.

In the Canvas Size window, the current width and height of your image are displayed at the top. You can then enter the desired new width and height below that. Pull-down menus let you select your preferred unit of measurement.

At the bottom of the box you can select an anchor position. This determines where the new canvas area will be added around your image. If you leave the anchor (indicated by the dark-gray box) in the center of the grid, the new canvas will be added equally around all sides of your image. If you anchor your image at the bottom left, the new canvas will be added above and to the right of the image.

Increasing the canvas size gives you room to add text around an image.

SAVING IMAGES

This might sound like a trivial topic—until the first time you look for an image and can't find it. Saving your images wisely makes it easy to retrieve them and can help optimize them for Internet use.

To save a new image, go to File> Save. The Save As window will then appear. In it, you can set the destination for your new file, enter the name of the file, and select a file format. Then hit Save. With some file formats, a second window will appear—often offering you compression options. Set these as you like. After you have saved a file once, going to File>Save will update that same file with any changes you have made (no window will appear).

Making a Backup

When you are working with digital images, especially those from a digital camera, your original file is essentially your negative—the image as you shot it. One of the marvelous things about digital imaging is that you can mess around with an image today, and tomorrow (when you decide your grandmother might not find it all that funny to see her head on a monkey), you can just start over from the original file.

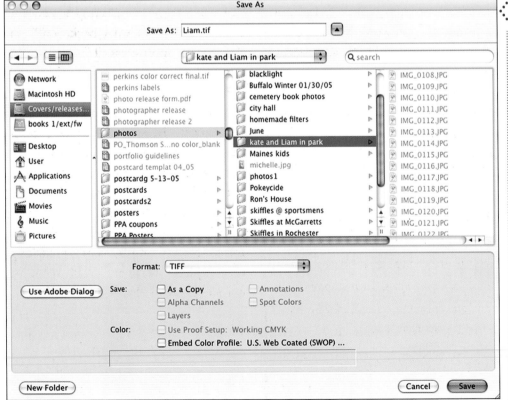

The Save As window lets you specify the location where you want your image saved. Type the name you'd like for your image in the Save As field, and select the desired file format from the Format pull-down menu. You can also choose to save the file as a copy (good for making backups) or to preserve layers in the image (see chapter 7). Advanced users can also choose to imbed a color profile for their monitor.

In the Save for Web window, the image on the left is your original, and the one on the right is a preview of the image optimized for the web. Beneath the preview, you can see the total size of the file and the approximate time it will take to load. On the right-hand side of the window, you can adjust the settings to maximize the appearance of the image while minimizing its load time.

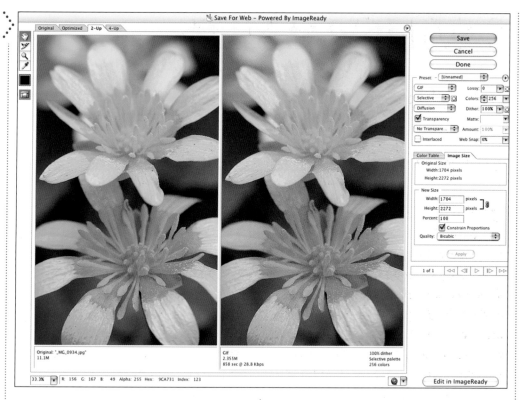

For this reason, it's important to make backups of your original images. Ideally, you'll probably want to burn these unaltered images to CD or DVD, ensuring that you won't be able to accidentally save over them and destroy your originals.

At the very least, when you start work on a new image, you should save it as a copy. You can do this by going to File>Save As and checking the "As a Copy" box near the bottom of the window, or simply by selecting a new file name (like "Grandma_backup.tif" or "beachshot_inprogress.tif").

Save for Web

To save an image for use on the Internet (on a web site or as an e-mail attachment), go to File>Save for Web. From the dialog box, you can select settings and see how long an image will take to load on a viewer's screen, as well as how it will look. You can even preview the image in your web browser by clicking on the globe icon near the lower right corner of the window.

SAVING FOR THE INTERNET

When you are saving images for use on the Internet, you need to consider both the image quality (how good the image looks on screen) and the load time (how long it takes to appear on your screen). Typically, load times are reduced by eliminating data—and this reduces the visual quality of the image. There's no one setting that will work with every photo, but if you spend a few seconds playing with the settings in the Save for Web window, you can almost always improve your load time without making too big a sacrifice in image quality.

GETTING HELP

The Help files in Photoshop can be your best friend when trying to tackle a tricky problem or locate a setting that you rarely need to access. They may even provide you with some new ideas.

While digital imaging is a tremendously exciting and powerful tool for photographers, there's no denying that the learning curve is steep. The help files are a great resource wherever you are on that curve, providing exhaustive information that covers everything from the most basic concepts to the minute details of tool options and program preferences.

Help Menu

The Help menu gives you access to Photoshop's excellent Help files. Many of the most commonly asked questions are grouped under headings at the bottom of the menu. If you find your question listed here, just click on it to go directly to the related file in Photoshop Help. If you don't, click on Photoshop Help at the top of the menu.

The Help menu gives you direct access to some commonly asked questions and to Photoshop Help.

Help	
Photoshop Help...	⌘ /
Welcome Screen...	
Export Transparent Image...	
Resize Image...	
System Info...	
Registration...	
Activate...	
Transfer Activation...	
Updates...	
Photoshop Online...	
How to Create Web Images	▶
How to Customize and Automate	▶
How to Fix and Enhance Photos	▶
How to Paint and Draw	▶
How to Prepare Art for Other Applications	▶
How to Print Photos	▶
How to Work with Color	▶
How to Work with Layers and Selections	▶
How to Work with Type	▶
How to Create How Tos	▶

To automate a task
To customize palettes
To customize tool presets

The Adobe Help Center is extremely useful when you need information on just about any topic related to Photoshop.

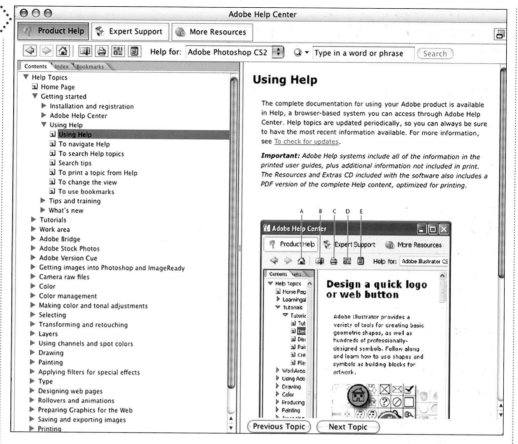

Photoshop Help

Opening Photoshop Help (Help>Photoshop Help), causes a separate application, called Adobe Help Center, to launch. If you're familiar with the use of a web broswer (like Netscape or Explorer), you'll have no problem figuring out how to use this software.

At the top left of the new window that appears, click on Product Help. (*Note:* Expert Support is a fee-based service from Adobe; More Resources takes you to online help and training web sites.) Below the Product Help button are several icons. From left to right, these are: previous page (left arrow), next page (right arrow), and home—just like on a web browser. The book icon allows you to bookmark a page for future reference (you can access book-

marked pages in the left pane of this window by clicking on the Bookmarks tab). Using the printer icon, you can also make a hard copy of the right pane (where the answers to your questions appear). This can help reduce the need to flip back and forth between Photoshop and Adobe Help Center.

Continuing to the top right of the palette is a window in which you can enter search topics. Just enter what you're looking for and hit Search. Topics related to your search will appear in the left frame. When you click on the topic here, the appropriate Help file will appear in the right frame. Some topics have multiple parts, which can be accessed using the Previous Topic and Next Topic buttons at the bottom of the right frame.

CHAPTER THREE

Cropping and Orientation

Before you get started working on an image, you'll often need to rotate it, crop it, or even adjust for perspective problems. These are quick procedures when you are using Photoshop.

DUPLICATE, ROTATE

These are some very basic operations—but they are so common that you'll probably use one or both of them on almost every image you work with.

If you've just scanned an image or just imported an image from your digital camera, it's an extremely good idea to make a duplicate of the original before you begin manipulating it in Photoshop. You may think you won't make any mistakes—but, like the rest of us, sooner or later you will. And when that mistake is accidentally saving an edited version of an image over the only original, it can be very frustrating—especially if you wanted to try some other effects on that original before deciding which you liked best.

Duplicate

To quickly make a backup of your image, you can simply go to Image> Duplicate. In the box that appears, you can rename your duplicated image, or use the suggested name (which will be your current file name plus the word "copy"). When you hit the OK button, a duplicate image window will appear in the Photoshop workspace. This will be the copy of your original image, and you can begin working on this copy without altering your original. This procedure also works well when you are in the process of working on an image and want to compare before and after versions side by side. Just duplicate the

In the Duplicate Image box you can rename the new image, or leave the suggested name (your original image name plus "copy") in place.

"before" image, make your change on the copy, then position the images side by side on your screen and decide which one you like the best.

Rotate

Under Image>Rotate Canvas, the drop-down menu contains options for rotating your image. When you shoot with a digital camera, this is the function you'll use to properly orient your vertical

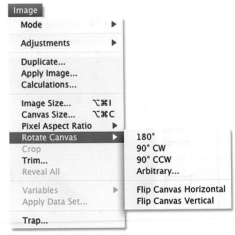

Under the Image menu, you can duplicate or rotate your image.

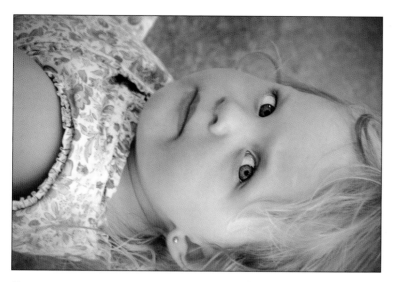

To take a vertical photo, you tilt your digital camera. When these images are transferred to your computer, they will appear as horizontals, though (above). To get the proper orientation, just rotate them 90 degrees to the left or right (right).

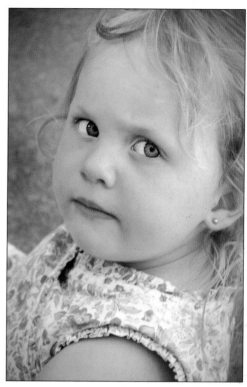

images (the ones shot with the camera turned on its end). Depending on the image, you can decide whether it needs to be rotated 90 degrees clockwise or counterclockwise. You can also rotate it 180 degrees—useful if you scanned it upside down (or shot it upside down during your trapeze lesson).

There are some other options for rotating your images—but you probably won't use these quite as often. First, you can select Image>Rotate Canvas>Arbitrary and choose a specific angle to which you want the image rotated. Extra blank space will be added around your image to accommodate this rotation, and its

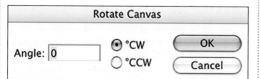

Enter the angle to which you want to rotate the image, note whether it is to the left or right, then hit OK to rotate.

color will be the color you have set for the background color (see pages 100–101).

You can also flip your images horizontally or vertically. This can be useful when scanning slides or negatives, which are easy to flip the wrong way in the scanner.

ANOTHER WAY

From Bridge (File>Browse), you can also easily automate the rotation of images. To indicate that a given image should always be rotated when Photoshop opens it, click on the thumbnail of the image and, at the top right of the window click on the appropriate directional rotate icon.

TRANSFORMATIONS

With architectural subjects in particular, photographing from an angle (like looking up at a tall building) causes some distortion. Eliminating this gives your photos a more professional look.

When photographing a subject with strong geometric lines, you get the best results when you keep your camera square to the subject—but sometimes this isn't feasible. For example, unless you have an extreme wide-angle lens or can shoot from far away, you normally can't keep your camera square to the subject when photographing a tall building from the ground. This is such a common problem that Photoshop has special tools to help fix it (and to create some other interesting effects, if you like). The first tools we'll look at are found under Image>Transform. A new tool in CS2 called Lens Correction also performs the same function; we'll look at this on pages 80–81.

Getting Started

Transforms can be done to layers (see chapter 7) or selections (see chapter 8). For now, before applying any of the following effects, go to Select>All. You will see a blinking dotted line appear around your entire image, indicating that the changes you make will apply to the entire image. For this reason, you should strongly consider working on a duplicate file (see page 29). When you've moved on to learn about layers and selections, you can use them when

From the Image>Transform pull-down menu, you can select several types of transformations.

applying transforms—but this will give you a feel for the process.

The Basics of Transforms

When you select any of the options from this pull-down list, an indicator box with handles (the small boxes at each corner and in the centers of the sides) will appear over your image. If you can't see the edges of your image, reduce your view of the image until you can see your whole image and some gray area around it (see pages 18–19). By clicking and dragging on these handles, you will manipulate the image data within the frame of the photograph. Which option you select from the Transform pull-

The photo on the left was taken from slightly below and to the left of the window. As a result, the vertical and horizontal lines are all slightly skewed and the window seems distorted. Going to Image>Transform>Distort allowed the image to be "undistorted," resulting in a better image (right).

down menu will dictate how you will be allowed to move the handles.

Free Transform
When you select this option, you will be able to move the sides, top, and bottom of the image in or out and up or down.

Skew
With this option selected, the handles will move only in a straight line in a given direction.

Distort
With the Distort function selected, the handles will move freely in all directions.

Perspective
When you select Perspective, the adjustments you make are mirrored top to bottom and/or left to right. If you move the bottom-left handle in toward the center of the image, the bottom-right handle will also move an equal distance in toward the center of the image. This is a good choice for images where your camera was only tilted in one direction (like up toward a tall building).

Accept or Decline
Hit Enter to accept the change. If you want to use more than one choice from the Transform menu, you can just choose it without first accepting the existing change (i.e., you can switch back and forth, *then* hit Enter to apply the cumulative changes). If you don't like the change, click on another tool from the Toolbox and cancel the transformation when prompted.

CROPPING

One of the quickest ways to improve the look of many images is by cropping out areas that distract the viewer from your subject. Cropping also changes the image size, though, so it needs to be done carefully.

The Crop tool (see page 13) is used to remove extraneous areas from the edges of a photo. This is a great way to improve the look of photographs you didn't have time to frame carefully or ones that you just didn't compose as well as you might have liked.

To crop an image, choose the Crop tool from the Toolbox. Click and drag over the area of your image that you want to keep, then release your mouse button. You don't have to be incredibly precise. At each corner of the crop indicator (the dotted line) you will see small boxes. These are handles that you can click on and drag to reshape or reposition the box. (As you get near the edges of the photo, these handles tend to "stick" to the edges. To prevent this, click on the handle you want to drag, then press and hold the Control key while moving the handle.) When the cropped area looks right, hit Enter.

Straightening Images

The Crop tool can also be used very effectively to straighten a tilted image. Simply click and drag over the image with the Crop tool, then position your mouse over one of the corner handles

Cropping is a great way to eliminate distractions from an image.

Cropping is a quick way to straighten out a crooked image, but you do lose some pixels in the process. Here, it's not a problem, but it could be more of an issue in other photos.

until the cursor's arrow icon turns into a bent arrow icon. Once you see this, click and rotate the crop indicator as needed. Doing this may cause the edges of the box that indicates the crop area to go outside the edges of the image. If this happens, simply click and drag on each one to reposition it inside the frame.

Crop Tool Options

In the Options bar at the top of the screen you can set the final size of the cropped image. This is helpful if, for instance, you specifically want to create a 4x6-inch print to frame. Simply enter the desired height, width, and resolu-

CROPPING AND RESOLUTION

Cropping reduces the total number of pixels in an image. If you are scanning an image and plan to crop it, you may therefore wish to scan your image at a higher resolution or enlargement to compensate for this reduction. If you are working with an image from a digital camera, the total number of pixels in your image is fixed, so you'll need to determine the final resolution and image size you need and not crop the image to a smaller size than that.

tion needed before cropping, then click and drag over the image to select just the area you want in your print. The Crop tool will automatically constrain itself to the desired proportions.

Also in the Options bar is a setting for the shield color and opacity. This shield obscures the area you are cropping out, giving you a better idea of what the photo will look like with these areas removed. Leaving it set to black will usually be fine, but you can change the color by clicking on the rectangle to the right of the words Shield Color. You can also adjust the opacity to allow the cropped-out area to be partially visible. To turn off the shield, uncheck the box to the left of Shield Color.

Select to Crop

You can also use any of the selection tools (see chapter 8) to crop an image. To do this, select any area of the image, then, with the selection still active, go to Image>Crop.

Basic Color and Exposure

Most images can benefit from at least a little tweaking of their color and exposure—after all, now that the control is in our hands (instead of the lab's), why not strive for perfection?

ADJUSTING COLOR

Making color look right is challenging, but it's probably the most important thing you can do to make your images look their very best.

As people who see color all around us every day, we are very savvy about color—we know how things are supposed to look, and when they aren't right, we notice it. Even if we don't know exactly what the problem is, we still see it. The following are some of the challenges to be aware of as you begin working with digital color.

Color is Subjective

Color is subjective. As a fact of biology, our eyes actively work to preserve the appearance of object colors in changing light, to enhance color differences between objects and their surroundings, and to inform our perception of color using our memories of what objects look like. While this is a marvelous thing in terms of survival (differentiating poisonous berries from ones that are safe to eat, seeing the green snake hiding in the foliage up ahead, etc.), it makes things tricky for people concerned with reproducing colors accurately.

Color Vision

Evolution has decided for us that as the brain sorts through the data it receives from the eyes, it should try to standardize it in order to give us the best possible information by which to survive. As

a result of this, blue objects always look blue—whether we see them under fluorescent, natural, or incandescent light. This is because we don't determine the color of an object in isolation—our perception of one color is linked to our perception of the colors around it.

You can experiment with this by turning on an incandescent light in a room that has previously been lit only by the sun. At first, the light from the bulb will look pretty orange. Your eyes will quickly compensate for this, however, and it will begin to look white.

Luminous Sources

When we look at a source of light, our eyes are constantly adjusting to it. That means that the longer you stare at your

JUST WALK AWAY

Sometimes you'll reach a point where you aren't sure if your corrections are helping at all. When this happens, it often helps to walk away from the monitor for a little while and relax your eyes. When you return to your image, you'll often be able to see immediately what steps are needed to make it look better.

image on the monitor, the better it sometimes looks. This can make you think it's okay when it's not. The luminous monitor also makes our pupils close down, which can lead us to think an image is darker than it really is. (For more objective information on your images, try using the Eyedropper tool, discussed on pages 46–47.)

Viewing Area

Your eyes will adapt to your monitor no matter what you do, but taking control of your viewing environment can help. Start by selecting a neutral gray for your computer's desktop pattern, since the colors you see *around* the edges of an image can affect how you perceive the colors *in* the image. The color of the environment around the monitor can also cast color reflections onto it, so try to keep the area neutral and constant. If possible, place your computer in a room with white or gray walls and position it so that there is no glare on the screen. Wear dark, neutral-colored clothing when working on color-sensitive projects, and try to keep the light *levels* in the room low and the light *types* constant throughout the day, and from day to day.

Even relatively small variations in color can make a big difference in a photograph—especially where skin tones are concerned.

AUTOMATIC CORRECTIONS

It may sound too good to be true. Can a single operation really make your images look that much better? Sometimes yes, sometimes no—but it's almost always worth a try!

If you've ever had the experience of developing or printing either color or black & white images in a traditional darkroom, you know that getting the tones in your images just right can be a laborious task. With the automatic image-correction functions in Photoshop, however, it's amazingly simple to create dramatic improvements.

That's the good news. The bad news is that Photoshop is, after all, a piece of software—it's not equipped with human vision. To compensate for this shortcoming when making its automatic corrections, it is therefore forced to assume what the scene or subject is supposed to look like.

Photoshop assumes, for instance, that you probably want there to be at least a small very dark area and a small, very light area. This is, in general, characteristic of a well-exposed image with good contrast. If you are working with a softly lit image of a tree in dense fog, however, this assumption isn't going to make your photograph look very good at all.

The software also makes assumptions about the overall lightness and darkness that an image should have and about how the colors in the image should be balanced. When your images

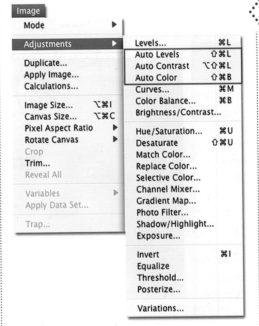

Go to Image>Adjustments to access the automatic correction features.

match these assumptions (and many photos actually do—they didn't pull these assumptions out of midair, after all), you are likely to get pretty good results—maybe even great ones—from the auto functions. When your photos don't match these assumptions, however, the results achieved can be flat-out scary.

That said, it only takes a couple of seconds to figure out if these methods will give you the results you want, so it's almost always worth a try. Just be prepared to hit Edit>Step Backward if you aren't happy with the results.

The original photo (top left) lacked contrast and had a yellow color cast. The Auto Contrast (top right) helped the contrast but not the color. The Auto Levels (bottom left) improved both the color and contrast, taking the image to a sepia tone that is probably close to what it originally looked like. The Auto Color (bottom right) fixed the contrast and eliminated the color cast, rendering the photo in pure black & white tones.

Auto Contrast

The Auto Contrast command, as the name implies, adjusts the contrast of your image—and only the contrast. It will not help any color problems that might be present in your photograph. If the contrast in the image you are working with seems a little flat or dull, but the color looks okay, this would be one strategy you could try.

Auto Levels

Auto Levels performs a correction that is similar to Auto Contrast, except that it also affects the color of your image. Theoretically, this should remove any overall color cast—but if your image doesn't have an overall color cast, it might actually add one. Still this is worth a try for images that need a little more contrast and have an obvious color cast you want to remove.

Auto Color

This is the most sophisticated of the three automatic functions—and it works remarkably well on a lot of images. While it sometimes introduces color problems, in many images it will be all you need to get the color and contrast to a point that is quite acceptable.

BRIGHTNESS/CONTRAST

One of the easiest ways to improve the overall look of your image is to increase the brightness and/or contrast slightly—but don't go overboard or the results can be really unappealing.

The *brightness* of an image refers to its overall lightness or darkness. The *contrast* of an image refers to the difference in brightness between the lightest and darkest tones in that image. Ideally, we can adjust these variables to produce an image with a full range of tones (from very dark to very light), where the subject is represented accurately (not too light or too dark).

However, the Brightness/Contrast tool can quite easily be overused. If you make an image too bright, too dark, or too contrasty, you will lose detail in some part of that image. This may be acceptable in some cases, but it is usually not desirable—so adjust these settings carefully.

To adjust the brightness or contrast of an image, go to Image>Adjustments> Brightness/Contrast. This will open a dialog box. Usually, you'll want to increase the contrast (move the slider to the right of center). Keep an eye on the darkest and lightest areas of your image as you do so. If you adjust the contrast so that it is very high, you'll see that these areas will start to lose detail (becoming pure white or pure black). If you want to create a natural-looking image, this is something you generally want to avoid.

Use your best judgment when adjusting the brightness of the image. Depending on the subject matter, the style of the image, and the look you are going for, the adjustments you make may vary widely from image to image.

Two examples of these adjustments (one good and one bad) are shown on the facing page.

To open the Brightness/Contrast dialog box, go to Image>Adjustments> Brightness/Contrast.

Increase the brightness or contrast of the image by moving the appropriate slider to the right of center.

Basic Color and Exposure

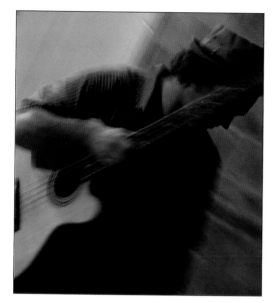

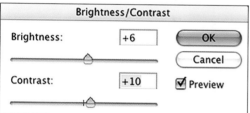

The original photo (top left) lacked a bit of contrast and was somewhat too dark. Adjustments were made in the Brightness/Contrast dialog box (above) to brighten the image and boost its contrast. The resulting image (top right) shows an appropriately subtle improvement.

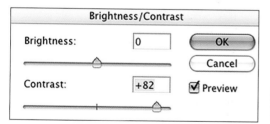

Beginning from the same original photograph as at the top of the page, the contrast was increased much more (above). The result (right) is very *dramatic*—and this very graphic look might be just what you want in some circumstances. The photo is not, however, *realistic*—there is none of the detail we'd usually like to see in a photo. This is especially evident in the highlights and shadows, which are pure white and black.

Basic Color and

OTHER TOOLS

The Image>Adjustments menu contains some extremely useful and intuitive tools for getting your colors just right—or for changing them completely, depending on what you want to do with your image.

In addition to color corrections, the Image>Adjustments commands also offer some creative possibilities.

Hue/Saturation

This command allows you to select a range of colors from an image (say, all of the reds) and adjust them without changing the other colors.

To do this, select the color you want to change from the Edit pull-down menu in the dialog box. Check the Preview box at the lower right, then adjust the Hue slider. The Saturation slider allows you to adjust the color intensity. The Lightness slider does what its name suggests.

Check the Colorize box to render an image in monotone color—excellent for creating sepia-toned images.

This color image was given a sepia look using the Colorize feature in the Hue/Saturation dialog box.

Desaturate

Going to Image>Adjustments>Desaturate lets you turn your color images to black & white.

Selective Color

This tool lets you pick a color (from the drop-down menu at the top of the dialog box) and adjust it in isolation by clicking and dragging on sliders for each color channel (see chapter 5).

Gradient Map

This command uses a gradient (see page 103) to apply color to your image. The dark tones in your image will be replaced by the color at one end of the gradient, while the light tones will be replaced by the color at the other end. The midtones will be replaced by the gradations in between. To try it, select a gradient from the pull-down menu in

In the Selective Color dialog box, setting the Edit pull-down menu to red and dragging the Hue slider to the left changed the red window frame to purple without affecting the other colors in the image.

This turtle underwent drastic color changes with the Gradient Map command.

The Variations lets you pick from different versions of your image. Click until the "current pick" image looks right.

the Gradient Map dialog box and watch what happens.

Photo Filter

This tool lets you instantly apply common photographic filters for warming, cooling, etc., to your images.

Variations

With this tool, a box appears with your original image in the top and several preview images at the bottom. Click on these to apply the change shown—and

keep clicking box after box until your image looks just right. Using the buttons at the top right, you can change the highlights, midtones, shadows, or overall saturation. With the slider under these buttons, you can adjust the settings to make big changes with each click (coarse) or very subtle ones (fine). When the "current pick" image looks the way you want it, hit OK.

Invert

The Invert command switches the colors in an image to their opposites— blues become yellows, blacks become whites, etc. The resulting image is essentially a negative of the original.

Equalize

The Equalize command makes the brightest tone in the image white and the darkest one black, then evenly redistributes the other pixels in between. Adobe suggests using this as an initial correction to scans that look darker and flatter than the original images.

Threshold

Threshold converts images into high-contrast black & white photos. In the dialog box, adjust the slider to the left or right to control the tones. To learn how to read histograms (the jagged stuff above the slider), see pages 50–51.

Posterize

This limits the total number of tones, producing images with very little detail. In the dialog box, setting the number of levels at 2 produces an image made up of only two colors. With higher settings, more tones will be used.

Advanced Color and Exposure

The automated tools covered in the previous chapter are very useful in many situations, but sometimes they just don't provide the degree of control needed. Using the Levels, Curves, and Eyedropper tools in partnership will give you more precise control for enhanced results.

EVALUATING IMAGES

When you want to make the most of an image, you can't just start hitting buttons and hope everything will work out; you need a concise plan of action.

As with any endeavor, developing a plan of action before diving in will enhance your results. When you scan or open an image and notice that it needs to be color corrected (or if you open it *because* it needs color help), you'll need to figure out exactly what the problem is. The following are some of the things you should look for when trying to decide what to do.

Shadows and Highlights

One thing that can make any photo look less than perfect is the absence of at least some areas of deep black and bright white. For most images, achieving a pleasing look requires the use of the full range of tones from black to white. Our eyes adjust to see this full range of colors in the world around us, so if a photo lacks it, we immediately feel that the image looks flat or dull.

Ask yourself: Are the darkest areas in your photo dark enough? Are the lightest areas light enough? Some photos may have one problem, some may have both, and some may have no problem at all. If you are looking at a scanned image, keep in mind that scanning can negatively affect the image, so even if your original was good, you may still need to adjust the scan.

There are, or course, some exceptions. If you've taken a photograph of a marshmallow in a snow bank, there may well not be any deep, dark tones. In an image of a black cat in a coal bin, there may not be any areas of pure white. Such instances are very rare, however. There may also be instances where, for creative reasons, you choose not to use the full range of tones in your image. In that case, you can move on to the next category of analysis.

Neutrals

Neutral tones (areas of white or gray) are often the key to learning what's going on under the skin of a digital image. If the neutral tones have a color cast, chances are that the rest of the image does, too.

A good place to start is with the whites. Keep in mind, the whites you evaluate should be areas of pure white (or very close to pure white), like a cloud, a white piece of clothing, etc. Although we often refer to the "whites" of the eyes or to people's teeth as being white, they rarely are. Once you've identified an area to evaluate, examine it closely for any slight shifts in color. White that looks at first glance to be pure often turns out to be faintly yellow,

or blue, or pink. A small color cast may be fine; it's a subjective decision that is yours to make. For example, if white clouds on a blue sky have a slight bluish cast, that may not be objectionable. However, if that bluish color cast runs through your whole image and makes your subject's *skin* look blue, that could be a big problem indeed.

Grays should also be neutral in tone (not bluish gray or reddish gray). Here, the selection of an area to evaluate is much more subjective. Paved streets and gray rocks tend to be a reasonably neutral gray. Sometimes clothes and other fabrics are neutral gray (and this can be either light or dark). Shadows on white walls or backdrops are also fairly neutral gray areas.

Skin Tones

As humans, we are accustomed to seeing human skin tones all around us every day of our lives. Therefore, we all notice it pretty quickly when a skin tone just plain doesn't look *right*. We notice problems especially quickly in photos of people we know personally or see on a regular basis. Yet, from time to time, we all see images of people who look jaundiced, or seasick, or like they've spent far too much time in the sun.

There are a few reasons for this. First, skin tones vary widely from person to person and can change dramatically depending on the lighting, activity level, exposure to sun, and even the person's emotional state. Second, skin tones are also finely detailed and feature hundreds of shades of color rather than a few unified tones. Third, even subtle problems can be very obvious to viewers. While you can get away with the grass being a little off color, it's harder for viewers to overlook skin tones that miss the mark.

Because evaluating skin tones is a fairly detailed process, we'll examine the issue more closely on pages 60–61.

In most images, showing a full range of tones—from rich black to bright white—creates the most pleasing appearance. To evaluate this image, let's look at the black areas of the butterfly's wings. They seem rich, but you can also see that there is some detail that reveals the delicate texture of the wings; the areas are not *solid* black. Turning to the whites, the spots on the wings are very light, but they aren't *pure* white. This is exactly what we want. Compare this image with the photographs shown on pages 56 and 60, which have serious color and/or exposure problems.

DIGITAL COLOR

We looked at some of the basics of color on pages 8 and 9. Now, it's time to get a little more in depth, learning how the colors in our images are created and how to manipulate them effectively.

When it comes to tweaking the color in your images, it helps to get a little scientific. Understanding how colors are produced will make it easier to figure out what's wrong when they don't look right—and how to address the issue to get better results.

Primary Colors

There are two sets of primary colors, the subtractive primary colors and the additive primary colors.

The subtractive primary colors are red, green, and blue. These colors are called subtractive because the total absence of all of the colors in an area is what produces black. At the other extreme, the full-strength presence of all of the colors produces white. You can see this in the center of the diagram to the right, which shows the effect of combining any two colors (at the overlaps between primary colors) and all three colors (center). As noted on page 8, this subtractive mode, called RGB, is the color mode we'll use throughout this book.

The additive primary colors are cyan, magenta, yellow, and black. These colors are called additive because the total absence of all of the colors in an area is what produces white. At the

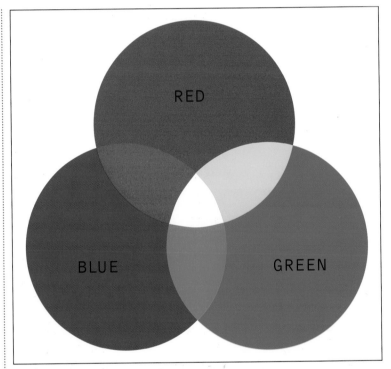

other extreme, the full-strength presence of all of the colors produces black. This color mode, called CMYK is used in professional offset printing (the type used for books and magazines). Getting top-quality results in the CMYK mode can be quite complex. If you need to prepare photographs for offset printing, you may wish to consult an avanced Photoshop book that covers this topic in detail. I would, of course, recommend my own book: *Color Correction and Enhancement with Adobe® Photoshop®* (Amherst Media, 2004).

At the center of the grouping, the presence of all colors yields white in RGB. When red and green are combined in equal amounts, the result is yellow. Combining blue and green in equal amounts produces cyan (bluish green). Combining blue and red in equal amounts produces magenta.

Color Recipes

Working in the RGB color mode, the amount of a primary color that is present in a given non-primary color is noted as a value that ranges from 0 (not there at all) to 255 (present at its fullest strength). This means that, in the digital world, we can identify individual colors using a pretty precise "recipe." This is extremely helpful when, for instance, we want to make sure that the colors in a sequence of images match (say, all the pale lavender bridesmaids' dresses at a wedding).

Color recipes are usually written something like this: R50/G120/B201. Looking at a recipe like this tells us that the red (R) value is 50, the green (G) value is 120, and the blue (B) value is 201. As you become more familiar with digital imaging, you'll be able to figure out what a color looks like just by reading the recipe.

For now, here are a few things to keep in mind. First, if all the values are 255, the color is white. If they are all 0, the color is black. If the colors are all the same value (but not 0 or 255), the color is a shade of gray. Also, the bigger the number, the stronger the presence of that color in the image. If all the numbers are high, the color will be quite light; if all are low, the color will be quite dark. Some examples are shown below to help you get a feel for this.

We'll be working with these concepts throughout the chapter, so don't be intimidated if they seem daunting—everything will become more clear as you put these techniques into practice!

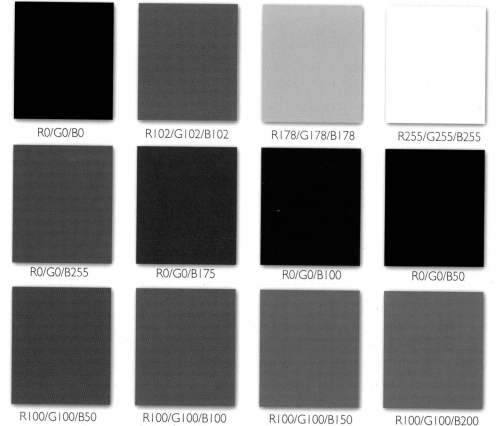

The R, G, and B values are equal in each color swatch. As the values get higher, the color goes from black, to shades of gray, to white.

R0/G0/B0 R102/G102/B102 R178/G178/B178 R255/G255/B255

Only blue (B) is used. As the numbers get smaller, the blue gets darker.

R0/G0/B255 R0/G0/B175 R0/G0/B100 R0/G0/B50

The R and G values are constant. As the blue changes, the color shifts from green (weak blue), to gray (blue equal to red and green), to shades of blue (strong blue).

R100/G100/B50 R100/G100/B100 R100/G100/B150 R100/G100/B200

EYEDROPPER TOOL

As mentioned previously, your eyes will deceive you. Fortunately, the Eyedropper tool will not. Therefore, it can work as your "lie detector" when you want to make precise color decisions.

Once you've opened your image in Photoshop, you have two tools for evaluating it: your eyes and the Eyedropper tool.

On pages 42–43, we examined how our eyes—or actually, our brains—treat color subjectively and can sometimes fool us into thinking things look different than they actually do. This makes the objectivity of the Eyedropper tool especially valuable when you are trying to closely analyze colors.

The Eyedropper tool samples colors, allowing you to see the precise color value of the pixels (displayed in the Info palette) as you evaluate an image. This information is expressed in terms of the RGB values that make up the colors, as discussed on pages 44–45.

With the Eyedropper tool selected, in the Options bar you can select the sample size you want. You can choose to see the values for one pixel (Point Sample) or a larger sample, a 3-by-3 or 5-by-5 pixel area. With the larger sample, you get a better idea of the overall color of the area. This is generally preferable, since color problems are more the result of overall trends than problems with one pixel.

To see how this works, review the example on the facing page.

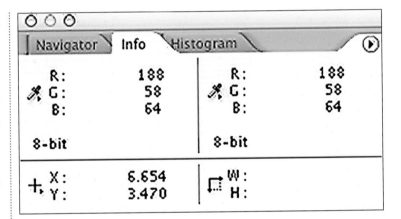

The Info palette (top) shows you the data gathered by the Eyedropper tool. If the color mode you're working in is not shown, click on the eyedropper icon in the box and select the desired mode from the fly-out menu that appears (above).

From the Options bar for the Eyedropper tool, select 3 by 3 Average.

1 Open an RGB image in Photoshop and select the Eyedropper tool.

2 In the Options bar at the top of the screen, set the sample area to 3 by 3 Average. This allows you to read the average value of three pixels within the area you click on in the next step. This averaged reading provides a better sense of the tone and color of the area than reading a single pixel.

3 Next, verify that the Info palette is visible on your screen. If it's not, go to Window>Info.

4 With the Eyedropper tool still active, move your cursor over your image and watch the Info palette. You'll notice that the RGB value change as you mov the cursor over dif ent areas of the frame. Move the c sor to dark areas areas, and areas different colors.

Histogram		
R:		252
G:		248
B:		250
8-bit		
W:		
H:		

values in the highlight area on y are all very high. This tells us ost white.

Histogram		
50	R:	250
57	G:	57
84	B:	84
8-bit		
207	W:	
360	H:	

hen a red flower is sampled, the R e B value is also a bit high (com- value), indicating that this leaf is a n called magenta.

LEVELS—THE BASICS

The Levels are a slightly more complicated way of adjusting the tones in your image (compared to the automatic methods in chapter 4), but they also offer a greater degree of control for fine adjustments.

The color- and exposure-correction tools we've looked at so far offer quick solutions to some problems, but they don't provide much precision. With the auto commands (Auto Contrast, etc.), you either like the results or you don't—there's no way to fine-tune them. With functions like Brightness/Contrast, your adjustments change all the tones equally. So what if you want to darken the shadows without changing the rest of the image? What if you want to brighten the midtones (all of the areas of middle brightness that are neither shadow nor highlight) without impacting the shadows or the highlights?

To accomplish these tasks and take control of the colors and tones in your image, one tool you can use is Levels, which lets you make changes to just the midtones without affecting the shadows, or just the highlights without impacting the midtones, etc. The result is a much greater degree of control.

The Dialog Box

The following is an overview of the features of the Levels dialog box. Don't worry if the individual elements seem a little abstract—on the next few pages we'll look at some practical examples that will make everything clear.

Image		
Mode	▶	
Adjustments	▶	Levels... ⌘L
		Auto Levels ⇧⌘L
Duplicate...		Auto Contrast ⌥⇧⌘L
Apply Image...		Auto Color ⇧⌘B
Calculations...		Curves... ⌘M
		Color Balance... ⌘B
Image Size... ⌥⌘I		Brightness/Contrast...
Canvas Size... ⌥⌘C		

When you open the Levels dialog box, the first thing you'll probably notice is a jagged black shape in a white window (1, facing page). This is called a histogram, and it is a graphic representation of the tonal values in your individual image. This histogram is one of the most valuable features of the Levels tool, since it gives you a totally objective way to evaluate your image.

Under the histogram are three triangular sliders. At the left is the black shadow slider (2), under the area of the histogram that shows dark tones. In the center is the gray midtone slider (3), under the area of the histogram that shows the midtones. On the right is the white highlight slider (4), under the highlight area of the histogram. The taller the histogram is above each area, the more of the tones in the image fall into that tonal range. By clicking and dragging these sliders, you can change

To access the Levels, open an image and then go to Image>Adjustments>Levels.

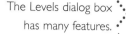

The Levels dialog box has many features.

the tonal range and contrast of your image (see pages 52–57 for further details on this process).

At the top of the box is the Channel menu (5). There is one channel for each primary color in your image—red, green, and blue—as well as a composite channel for all three together (RGB). As we'll see on pages 56–57, this gives you some powerful ways to adjust colors.

When using Levels, make sure that the Preview box (6) is checked so that you can see the results of your changes.

At the bottom right are three eyedroppers (7). From left to right, these are the Set Black Point eyedropper, the Set Gray Point eyedropper, and the Set White Point eyedropper. These will be covered in detail on pages 58–59.

Clicking the Auto button (8) does the same thing as the Auto Levels. See page 37 for more on this.

The Save and Load buttons (9) allow you to store your settings and ap-

ply them to other images. The OK and Cancel buttons (10) are used to accept or decline any changes made in the dialog box.

The Input Levels (11) show the range of tones in the image. Each box corresponds to one of the sliders under the histogram. In the RGB color mode, the left box will read 0 (zero) for pure black and corresponds to the black slider. The box on the right will read 255 for pure white and corresponds to the white slider. The middle slider corresponds to the midtone slider and will be set to 1.0. If you move the sliders, you will notice that the values change.

The Output Levels (12) allow you to control the extent of the tonal range in the final image, normally to ensure that it does not exceed the capabilities of an output device. This is not an important feature for most people—unless you are printing images on an offset printing press.

READING HISTOGRAMS

Reading the histogram for your image can tell you quite a lot about it. Even if you didn't know what the image looked like, you could get a pretty good idea about its basic characteristics.

Probably the most useful component of the Levels dialog box is the histogram. Using this graphic representation of the tones in your image, it's easy to get a good idea of where there might be problems. Let's look at a couple of examples using the Levels to evaluate an image. The images below are each paired with a screen shot of the Levels dialog box. The histogram for

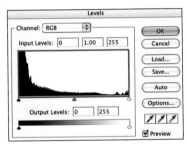

In an image where the tones are primarily dark, the histogram data is concentrated to the left near the shadows slider.

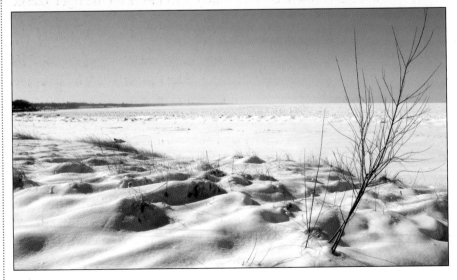

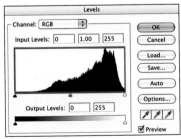

In an image where the tones are primarily light, the histogram data is concentrated to the right near the highlights slider.

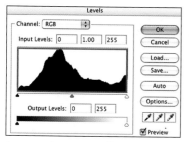

In most images, you'll see that the data is more evenly distributed across the entire range of the histogram. Compare this image and histogram with the ones on the facing page.

each is boxed in orange. As you can see, the histograms are very different.

If you look at the winter scene (facing page, bottom), you'll notice that the tones in the image are almost all white or very light. Now, look at the screen shot next to that image. In this example, the histogram is very tall near the highlight end of the histogram. That tells us that most of the tones in this image are pretty bright. Notice the height of the histogram over the midtone slider—it's much lower. This tells us that fewer of the tones in the image fall into this category. Now, look at the histogram above the black slider. As you can see, there's nothing there; none of the tones

in this image are pure black. From evaluating the histogram, you can see one quality of this image that might need attention.

If you look at the image of the rundown train station (facing page, top), you'll see that quite the opposite is true. The histogram in the region of the black slider is very high, and very few tones fall into the midtone category. Looking at the histogram over the white slider, you can see that very little of the image (the bright windows on the right side of the image) displays this level of brightness. Even if you did not have the image to look at, you could tell just by looking at the histogram that this is an image with predominantly very dark tones, that some tones are a bit lighter, and that a very small amount of the image is made up of very light tones.

In most images, you'll see that the data is more evenly distributed across the entire range of the histogram, as seen in the photo above and the screen shot to the left of it.

DIGITAL CAMERAS

Photoshop isn't the only place you'll find histograms—many digital cameras also allow you to display them for each image. Look for this under your camera's image-review settings. Learning to read histograms can, therefore, be an asset both when creating *and* editing your images.

ADJUSTING CONTRAST

Here's where histograms start to get really useful, giving you an indicator of potential problems with images—subtle things you might not notice at first glance but that can improve your photos.

Now that you know the basics of reading a histogram, let's look at how these histograms can help you diagnose image problems—and how adjusting the sliders can help you correct them. In this lesson, we'll look at contrast.

The overall tonal range and contrast of an image is sometimes easier to evaluate objectively using the Levels histogram. In the example to the right, the low contrast of the photograph is obvious in the histogram, which shows that the tonal range of the image does not extend as much as it could into either the black or the white range. Unless this is intentional, you'd probably want to consider strategies for improving the contrast of such an image.

The quickest way to do this is to move the highlight and shadow sliders. Begin by moving the shadow slider to the right until it is just under the edge of the histogram data (you can ignore any flat little tail of data that might stick out here).

When you do this, you're telling Photoshop that the darkest tone in your image (represented by that far-left end of the histogram) should actually be black. Similarly, moving the highlight slider to the left until it is just under the

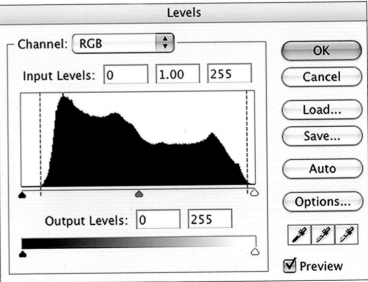

Notice how the histogram data stops short of the shadow and highlight sliders. This reveals that the tones in this image do not extend through the full tonal range from black to white. As a result, the image looks flat and muddy; it suffers from a lack of contrast.

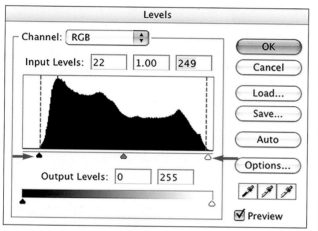

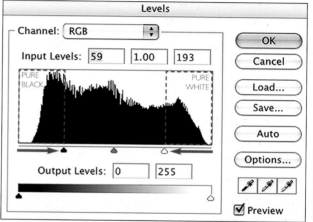

Clicking and dragging the shadow and highlight sliders in under the very edge of the histogram data above them fixes the contrast. The tones in this image (reflected by the histogram) now extend all the way from black to white.

Don't move the highlight or shadow slider in past the edge of the histogram—this will destroy the detail in your image. All the tones to the left of the shadow slider will be pure black; all the tones to the right of the highlight slider will be pure white.

edge of the histogram data tells Photoshop that you want the lightest tone in your image to be white. This operation is shown in the image and screen shot on the left (above).

If moving the highlight and shadow sliders in a little is *good*, moving them in a lot must be *better*, right? Nope. In the photograph and screen shot on the right (above), you can see what happens when you do this. When the shadow slider is moved in too far under the histogram, all of the image tones to the left of it in the histogram become pure black with no subtle detail. Similarly, all of the

tones in the histogram that fall to the right of the highlight slider become pure white with no detail.

For the majority of photos, ones where a realistic look is desired, this results in contrast that is too high. The areas of undetailed white and black can look especially ugly when printed, since this tends to make the problem even more evident than it is on-screen.

If you want a creative effect that doesn't need to be realistic, however, you might actually *want* to use this method to create an image with extremely high contrast.

ADJUSTING THE MIDTONES

If the highlights and shadows look good in your image but something still doesn't look quite right with the exposure, the problem is likely the midtones. Try brightening or darkening them to fix the problem.

For many photos, a simple adjustment to the midtones can make a big improvement. This is very easy to do in the Levels dialog box.

To brighten the midtones in an image, click on the midtone slider and drag it toward the black point slider. This may seem somewhat counterintu-

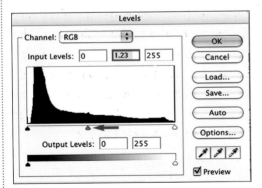

Here, the tones in the image are predominantly dark. This is just fine, but the skin tones and brightly colored t-shirts seem like they could be a bit brighter. Also, the subjects' dark hair doesn't stand out from the background very well.

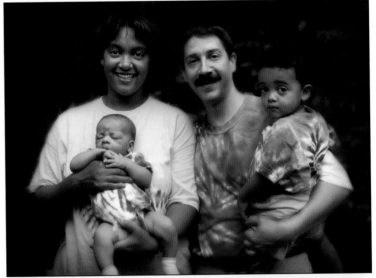

Moving the midtone slider slightly to the left makes the subjects stand out better from the background and gives a better representation of the colors. Don't go overboard with a change like this—the results can be quite unpleasant.

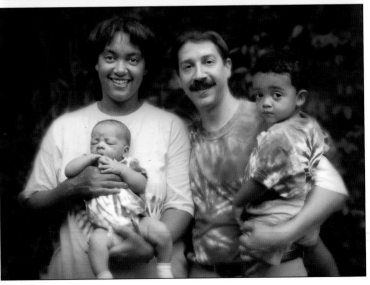

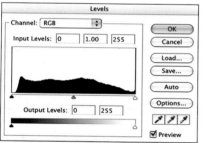

In this image, the tones are spread evenly across the histogram, but the skin tones look pretty pasty. They could be darker.

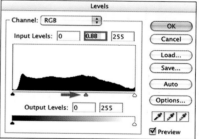

Moving the midtone slider a bit to the right darkened the midtones, making the skin tones look more healthy.

itive—wouldn't you want to drag it toward the highlight to brighten the image? Nope. Remember, the slider you are moving defines the midtone point. When you move it toward the shadow slider, that shifts the tones in the image so that more of them are *lighter* than the midtone (i.e., more of the histogram falls between the midtone slider and the white point slider than between the midtone slider and the black point slider). To darken the midtones in an image, simply move the midtone slider toward the white point slider.

A COMBINED APPROACH

The results you achieve using the auto color-correction functions can often be fine-tuned to great effect using the Levels command—especially when the results with the automatic tools are already close to what you want.

ADJUSTING THE CHANNELS

Here's where we get to the really powerful aspect of the Levels—the ability to deal with each primary color individually instead of collectively. This gives you greater control than any automatic tool.

As discussed on pages 44–45, the set of primary colors used to create the other colors in your image is collectively referred to as the color model or color mode. The individual colors within the set, on the other hand, are called channels. For example, if your image is in the RGB mode, then it has three channels: red, green, and blue.

Viewing the Channels

As noted on page 49, the Channels pull-down menu at the top of the Levels dialog box allows you to work on the

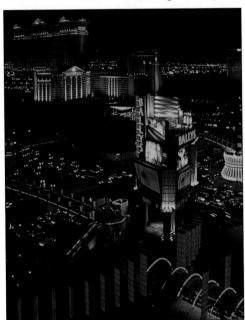

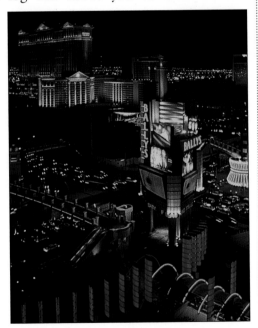

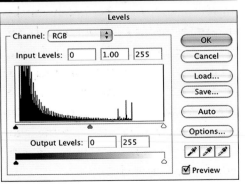

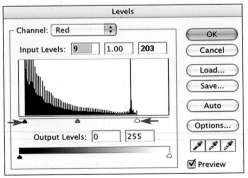

1 Open an image in the RGB color mode (far left, top). Then, go to Image>Adjustments>Levels to open the Levels dialog box (far left, bottom).

2 Pull down on the Channel menu at the top of the box and select the red channel. Move the highlight slider to the left until it is just under the edge of the data in the histogram. Then, move the shadow slider to the right until it is just under the edge of the image data in the histogram (bottom left).

3 Repeat this process for the green channel (right image and screen shot).

4 Repeat this process for the blue channel (far-right image and screen shot).

5 As you make each change, don't worry if the colors seem to shift in unpleasant ways; you can only see the final effect when you've completed the last change on the last channel.

6 If you want to fine-tune the results, go back into the individual channels or the composite RGB channel and try adjusting the midtone sliders.

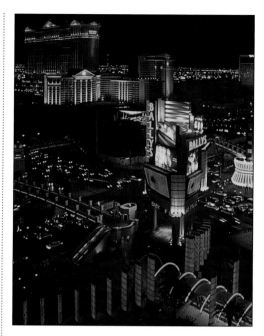

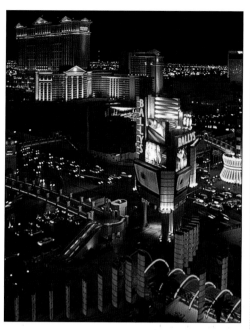

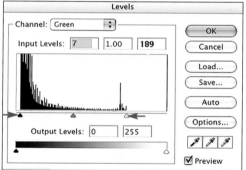

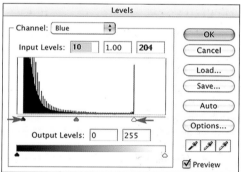

image as a whole (the RGB channel) or on individual channels one at a time.

Adjusting the Channels

By adjusting the individual channels, you can quickly remove a color cast while improving the overall contrast of your photograph. The basic procedure is easy to accomplish and can be adjusted visually to suit the individual image. Just follow the steps that begin on the facing page.

Keep in mind that you'll be able to see the changes most clearly if you work with an image that doesn't look perfect already. Here, the left image on the facing page lacks contrast and has an over-

all pinkish color cast. This makes it a good candidate for this technique.

Fine-Tuning the Results

When you have completed this process, your image (in most cases) should be better color balanced and have better contrast. Evaluate your image carefully, however, to ensure that the highlights are not blown out (lacking detail) and the shadows are not blocked up (lacking detail)—unless you want the image to look that way. If the color in your images doesn't look right, you may also want to make adjustments to the midtone sliders in one or more of the individual color channels.

THE LEVELS EYEDROPPERS

Want a quick one-touch correction? The eyedroppers may be just what you're looking for. With a little experimentation, these handy little tools can produce surprisingly good results.

The eyedroppers provide a quick way to remove color casts and set the overall tonal range of your photograph. To use them, simply open an image and go to Image>Adjustments>Levels. You can use one, two, or all three of the eyedroppers, depending on your needs.

Set Black Point

To use the Set Black Point eyedropper, simply click on its icon at the lower right of the dialog box (see page 49). Your cursor will then turn into an eyedropper. Move the eyedropper over the image and click on an area of the image that you want to become pure black. Assuming you have the Preview box checked (at the lower-right corner of the dialog box), the image will adjust instantly to reflect the change. Don't worry if it doesn't look perfect—you can click again and again until you get it just right. Be careful with this tool; you can easily create ugly, blocked-up areas of black with no detail.

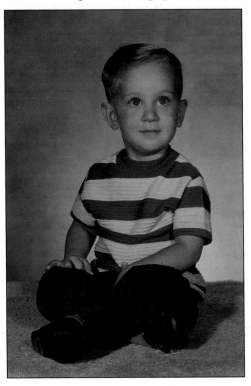

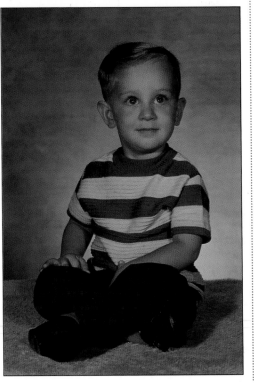

1 Photos often lose contrast and shift color over the years. The image on the far left mostly lacks contrast, but some color help won't hurt it.

2 To begin, the Set Black Point eyedropper was selected and clicked on a very dark shadow area of the little boy's shoe. This set that area to black. It also caused some of the other tones to shift (left)—but we'll fix that in the next step.

3 The Set White Point eyedropper was then clicked on a bright highlight next to the boy's left elbow (right). Alternately, you could click on one of the highlights in his eyes.

4 Since the pants should be neutral gray, the Set Gray Point eyedropper was clicked on them. This eliminated the pink color cast (far right).

Set White Point

You follow the same procedure to use the Set White Point eyedropper, clicking on an area of the image that you want to be pure white. If there's not a clear choice (like a very bright highlight), try clicking around on the image until you find the best choice. Be careful to avoid creating ugly areas of pure white highlight with no detail. You'll probably also see the color shift to some degree with each click as the colors in the image shift to neutralize the clicked-on area to pure white. You can click as many times as you want.

Set Gray Point

Whether or not you will want to use the Set Gray Point eyedropper will depend on the image. If there is no pure gray tone in the image, clicking on this image with this tool will cause some big color shifts as the tone you click on is set to neutral gray and the other tones in the image are all adjusted accordingly. If you do have an area that should be neutral, though, this can be a good way to eliminate a color cast.

The eyedroppers won't provide a solution to every problem, but they can be a very useful tool when applied selectively. Keep in mind, you can always hit Cancel (or go to Edit>Step Backward) if you decide you're not improving the look of the image.

WHOA!

Sometimes clicking with one of the eyedroppers will result in a rather shocking transformation, like a totally bizarre and unappealing color shift. Don't worry—it's no big deal. To fix the problem, just click somewhere else in your image or hit the Cancel button in the Levels dialog box.

SKIN TONES

Because of their vast variety and subtlety of tonality, skin tones are one of the most challenging things to perfect in an image. Often, combining multiple color-correction tools is required to get the results you want.

We see skin tones every day, so we notice it quickly when they just don't look right. Adding to this is the fact that skin tones are widely varied from person to person—and even across a single face. These subtle variations in tone can make it tricky to determine when the skin tones look just right in a given image.

Also, our eyes "help" us by trying to neutralize the subtle color casts that can make our subjects look bad. This makes it especially important to use the Eyedropper tool (see pages 46–47) when looking at skin tones. Unfortunately, there is no standard by which to judge "correct" skin-tone color because there *is* no "correct" color. The following guidelines may, however, be helpful.

First, you should use the Eyedropper tool to evaluate a median tone on the skin (not a highlight or a shadow). Avoid areas that tend to be pinker (like lips or fingertips) or where there may be shadows (eyelids, under eyes, knees, under chin, etc.). Good areas may include the forehead or jaw area, shins, forearms, etc. Avoid areas where the subject is noticeably tanned (unless the tan is all-over and even). The face is the first thing that most people look at in a portrait, so that's a good place to start.

For fair complexions in daylight, a good starting point would be in the neighborhood of R200/G170/B150. For darker complexions in daylight, a good starting point would be in the neighborhood of R170/G110/B80.

Keep in mind, these numbers are only for reference. If you take eyedropper readings off your subject's face and find that the green and blue values are pretty much in line with those listed above but the red is much higher, think about your subject. Is the person's skin actually a little redder than average? Was he or she blushing or flushed when you

The original photo lacks contrast and the skin tones are significantly too blue. The following steps show one possible way of correcting this—but you can combine tools in whatever way works for you. Don't be afraid to use a tool more than once to get the effect you want.

2 The first tool selected was Auto Contrast (top left). This helped the overall contrast, although the image now seems a little too dark.

3 Next, the Levels were used to brighten midtones, and the Set White Point Eyedropper was used to set the white point on a bright white highlight in the frosting (top right).

4 The Variations command was then used to decrease the blue and increase the red (bottom left).

5 The Eyedropper tool was used to evaluate the skin tones. This showed that they were still too blue.

6 The Levels were used again to increase the red in the midtones and slightly reduce the blue in the midtones (bottom right).

took the picture? If so, the color might be right on. If not, consider making an adjustment to the skin tones part of your strategy.

Also, these numbers should be considered proportionately, not as absolute values; if your subject's skin-tone readings seem to be more like R190/G160/

B140, that's probably just fine, since all of the colors are just proportionately a bit darker.

Finally, as you move into darker or more shadowed areas of the skin, expect the color to become somewhat more blue.

CURVES—THE BASICS

Thought the control you achieved with the Levels was really something? Well, you haven't seen anything until you start working with Curves, the most refined of Photoshop's color-correction tools.

What is it that makes the Curves the choice of professional image editors for adjusting color? The answer is simple: control. As you've seen in the previous lessons, the Levels tool is quite powerful but allows you only three points of control per channel (the shadow, midtone, and highlight sliders). The Curves tool, on the other hand, allows you to establish up to *fourteen* points of control—although using more than five is pretty rare. As you can imagine, this allows you to make much finer adjustments and to manipulate your images in ways that are impossible with any of Photoshop's other tools. If this sounds a bit daunting, don't worry—the effects preview instantly on your image so you can see the changes you're making.

The Dialog Box

Unlike the Levels tool, when you open the Curves tool the dialog box will look the same for every single image. The diagonal line running through the central area of the dialog box (1) is called the curve. It might seem odd to call a straight line a curve, but as you'll see, it is the bends you apply to it that change and enhance your image.

The gradient bars at the bottom and left of the curve (2) represent the tones

controlled by the proximate area of the curve. In the RGB mode, the dark tones are controlled by the lower part of the curve. The light tones are controlled by the upper part of the curve. If, for some reason, you'd like to reverse this, click on the black and white arrows in the center of the bottom gradient bar (3).

As in the Levels dialog box, the Channels pull-down menu (4) allows you to access the individual color channels for the image.

To change the tones in your images, you will generally click and drag on the curve line to change its position. If you prefer to draw the curve manually using your cursor, click on the pencil icon (5), then manually draw a curve over part or all of the existing curve.

If you choose to draw a curve manually, the Smooth button (6) will become active. Clicking on it will smooth

To access the Levels, open an image and then go to Image> Adjustments>Levels.

The Curves dialog box has many features designed to assist you in adjusting the tonality of your images.

the curve you draw, providing a more seamless transition between the tones in the image.

Because you may want to make very fine adjustments to the points that create the bends in your curve, Photoshop allows you to enlarge the dialog box by clicking on the icon at the lower right corner (7).

Make sure that the Preview box (8) is checked as you work on your image so that you'll instantly be able to see the results of the changes you are making.

The three eyedroppers (9) function the same as with the Levels. See pages 58–59 for more on this topic.

The Options button (10) gives you access to the Auto Color Correction Options settings. Clicking the Auto button (11) provides an automated correction of the image.

The Save and Load (12) buttons allow you to make adjustments to the Curves, then save them for later use. To access the saved settings for a second image, open that image and go to Image>Adjustments>Curves, click the Load button, and identify the previously saved settings.

When you're done, hit OK (13) or Cancel to accept your changes or cancel them.

EDITING CURVES

Envisioning the results you'll get when adjusting the curve line might seem a little tricky, but if you keep a few basic rules in mind, you'll find that it's actually quite easy.

Unlike the Levels tool, the dialog box for the Curves tool will look the same every time you open it. Since it will not, therefore, provide any information about the tonal balance of the image, it is especially important that you've already determined your goals for the image before you begin manipulating the curves. For a review of this preflight process, see pages 42–43.

Smoothness

The smoother you keep the curve, the better your results will look. You can create sharp bends and tight turns, but these will change the tonalities in ways that are not realistic and are generally not aesthetically pleasing.

Steepness

When you make the curve more steep than the 45-degree angle at which it starts, the result will be an increase in contrast. When you make the curve flatter or more shallow, the result will be a decrease in contrast. As you edit the curve, making one area more steep (more contrasty) will often result in other areas becoming more shallow (less contrasty), so you'll need to evaluate the image carefully to ensure you are happy with whatever trade-offs there may be.

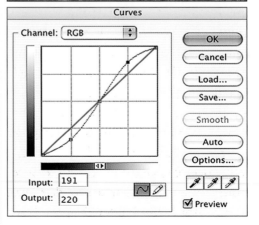

Keeping the curve smooth produces realistic results. A shallow S or C shape is usually desirable.

A jagged curve produces results that are pretty bizarre—and far from subtle.

Compare the original curve line (orange) with the edited curve (black). In the midtones, the line is now steeper, indicating an increase in contrast. In the far shadow and highlight areas, it is shallower, indicating a decrease in contrast.

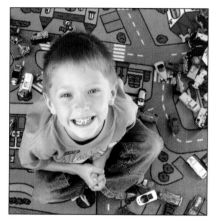

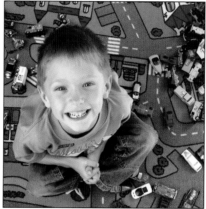

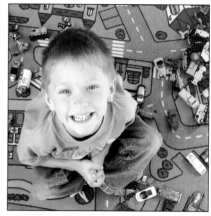

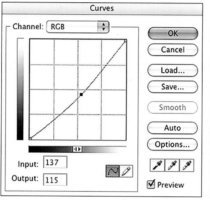

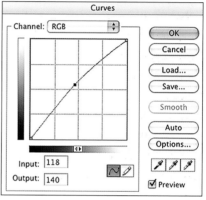

On the left (top and bottom), we see the original image and the unedited curve. Pulling down on the center of the RGB composite curve darkens the midtones (center top and bottom). Pulling up on the center of the RGB composite curve lightens the midtones (right top and bottom).

Adjusting the Midtones

One of the most basic changes you're likely to make is to the midtones of an image (those areas of the photo that are neither shadows nor highlights). In the screen shot under the portrait above (left) you can see the original straight line of the curve. By clicking on the midpoint of the line and dragging it down, the midtones in the image are made darker (center image and screen shot). Conversely, by clicking on the midpoint of the line and dragging it up, the midtones in the image are made lighter (right image and screen shot).

Looking at the center screen shot above, you can see that the black point (the lower-left point of the curve) has remained unchanged. The three-quarter tones (the tones that are darker than the midtones but lighter than the black point) are very slightly darker. They are also, as the more shallow angle of the curve line reveals, very slightly lower in contrast than in the original image. In such an instance, if you had very important areas of detail in the shadows, you'd want to double check them to make sure that no desirable detail was compromised.

The quarter tones (the tones that are lighter than the midtones but darker than the white point) are also very slightly darker, but they have experienced a slight increase in contrast (the line is a bit steeper than it was before the change). Again, if there was important detail here—say, the texture on a white wedding gown—you'd want to check these areas to ensure it was not compromised. Here, the white point, like the black point, was not changed.

CONTRAST AND CHANNELS

Now that you understand the basics, let's look at some practical examples—adjusting the contrast of an image and removing a color cast. These are everyday tasks that Curves make easy!

Adjusting the Contrast

Increasing the contrast in the midtones is a good way to add contrast to an image without blowing out the highlights or blocking up the shadows. Creating an S-shaped curve is the way to accomplish this.

Begin this process by clicking on the center of the curve to create an anchor point. If you want to darken or lighten the midtones overall, you can drag up or down on this point (as seen on pages 64–65).

Then, click on the curve line about halfway between the midpoint anchor you just created and the shadow point (the bottom-left point in the line). Drag this point slowly down toward the bottom of the box. As you do this, the upper half of the curve will mirror the bend in the bottom half. As a result, as you darken the three-quarter tones, the quarter tones will become progressively lighter. The greatest point of change will be at the midpoint anchor, so the greatest increase of contrast will be in the midtones.

Again, looking at the resulting curve tells the tale. Comparing the two screen shots to the right, you can see that the new curve (bottom) is now steeper in the center than the original (top). From

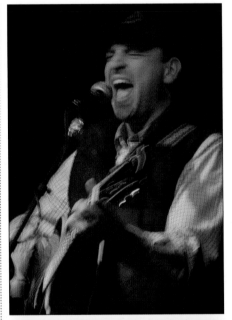

In the original image, the contrast was slightly too low.

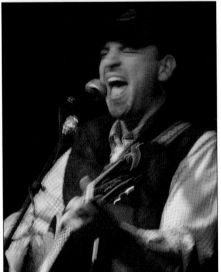

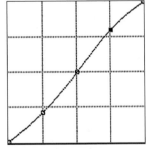

The contrast of the image was increased by adjusting the previously straight curve so that it became a shallow S curve.

1 Begin with an image in the RGB mode. Open the Curves dialog box by going to Image>Adjustments> Curves.

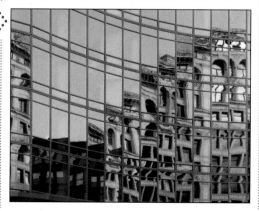

2 Decide what color needs to be removed. In this image, the building looked too blue. Therefore, the Blue channel was selected and the midpoint of the line dragged down until the color looked better.

3 Correcting the blue color cast revealed an underlying pink tone. To eliminate this, the Red channel was selected and the midpoint was dragged down very slightly.

4 After making these adjustments, the color looked much better. If you liked, you could continue to make changes to the midtones or contrast by switching the Channel menu to RGB.

the three-quarter-tone area to the shadow and from the quarter-tone area to the highlight, however, the curve is now slightly more shallow, meaning that the contrast in these areas has been slightly reduced.

Should you want to *reduce* the contrast in an image, follow the same procedure but pull *up* on the second anchor point (the one between the midpoint and the shadow). This will make the middle of the curve more shallow (less steep) but will to some degree increase the contrast of the highlight and shadow tones, so watch out for problems in those areas.

Removing a Color Cast

If an image has an overall color cast, you can remove it easily using the Curves.

To do this, you must first identify the nature of the color problem—is the image too blue? Too red? Too green? Maybe a bit too blue *and* red? Once you've decided what needs to be changed, go to the appropriate channel and pull down on the center of the curve until the color cast disappears, as shown in the steps to the left. Keep in mind that you may need to make adjustments to more than one channel to properly balance the color. Often, eliminating an obvious color problem reveals a more subtle underlying one that also needs to be addressed.

It's easy to go overboard with this, so try to work in small increments and consider each change carefully. After applying the Curves change, you can toggle between the before and after versions of the image by going to Edit> Step Backward and Edit>Step Forward.

Filters and Styles

The filters and styles in Photoshop offer instant gratification—and some pretty cool looks for your images. Be prepared to play with these for a while and marvel as they work a little magic!

ARTISTIC FILTERS

Getting started using filters is very easy—and the Artistic filters in Photoshop provide a variety of ways to give your image a very "painterly" look.

A filter is a specialized piece of software that runs within Photoshop and is used to apply a specific effect to an image. Many filters are packaged with Photoshop itself, and other filters (from Adobe and other companies) are also available to meet specialized needs. In this book, we'll stick to the ones that are packaged with Photoshop.

You can apply filters using the Filter pull-down menu at the top of the screen. Pulling this down will reveal sev-

eral submenu categories that contain the individual filters. Selecting a filter will cause one of three things to happen. For some filters, a full-screen dialog box called the Filter Gallery will appear (see below). This has a preview of the image on the left, icons for each filter in the center, and controls for the individual filters on the right. For other filters, a smaller dialog box that is unique to that filter will appear. For a few filters, the effect will automatically be applied to

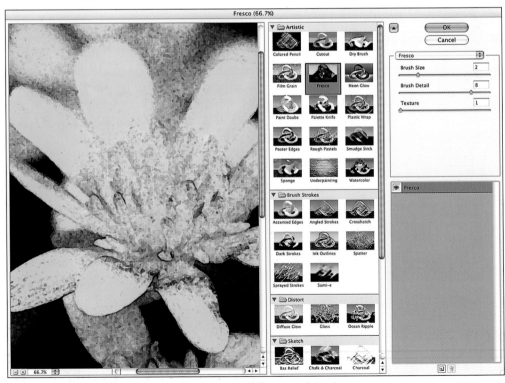

When you choose a filter from the Filter menu, a full-screen dialog box opens.

your image, without any dialog box at all appearing on screen.

Artistic Filters

The filters in this group are designed to imitate the effects of traditional artistic media. A few examples are shown below. Experiment with these filters and their settings as much as you like—you can always use the Edit>Step Backward command or the History palette to reverse the effect if you decide that you don't like it.

The filters included in this category are: Colored Pencil, Cutout, Dry Brush, Film Grain, Fresco, Neon Glow, Paint Daubs, Palette Knife, Plastic Wrap, Poster Edges, Rough Pastels, Smudge Stick, Sponge, Underpainting, and Watercolor. The best way to learn to use them is to open an image and begin experimenting with the settings.

Original image.

Colored Pencil filter.

Poster Edges filter.

Watercolor filter.

Film Grain filter.

Smudge Stick filter.

BRUSH STROKES AND SKETCH

Don't be afraid to experiment. Filters can produce some strange looks that aren't right for every image, but sometimes the right filter can instantly bring a plain image to life right before your eyes.

With these filters, adjusting the settings in the dialog box will radically change the effect. Spend some time adjusting the various sliders until you find the best look for your image.

Brush Strokes Filters

The filters in the Brush Strokes group can be used to add the look of natural brush strokes to an image. The filters in this category include: Accented Edges, Angled Strokes, Crosshatch, Dark Strokes, Ink Outlines, Spatter, Sprayed Strokes, and Sumi-e.

When you select the filter you want to apply, in this dialog box you will be able to set parameters for the length of the brush strokes and their pressure (the selections vary slightly from filter to filter, so be prepared to experiment). Be sure to use the preview window to adjust and evaluate the settings.

Original image.

Accented Edges filter.

Crosshatch filter.

Spatter filter.

Sprayed Strokes filter.

Sumi-e filter.

Original photograph.

Bas Relief filter.

Charcoal filter.

Photocopy filter.

Stamp filter.

Water Paper filter.

Sketch Filters

The Sketch filters imitate the look of the various media used in sketching, as well as some other paper-based artistic processes. These filters include: Bas Relief, Chalk & Charcoal, Charcoal, Chrome, Conté Crayon, Graphic Pen, Halftone Paper, Note Paper, Photocopy, Plaster, Reticulation, Stamp, Torn Edges, and Water Paper. The effect of each filter is controlled through a dialog box that opens when you select the filter. The best way to learn about these filters, and the best settings for them, is simply to experiment!

For best results, try using a black & white image. To convert a color photograph to black & white, simply go to Image>Mode>Grayscale or Image>Adjustments>Desaturate.

BLUR AND DISTORT

You may use the Blur filters with some frequency to soften an image (good for hiding little wrinkles), but use the Distort filters selectively—used too frequently, they can quickly lose their visual impact.

The Gaussian Blur is one of the most frequently used filters in Photoshop. Read on to learn why.

Blur Filters

The Blur filters let you reduce sharpness in an image. This can be useful for creating a soft-focus effect or for adding special effects (like a motion blur). The filters included in this category are: Average, Blur, Blur More, Box Blur, Gaussian Blur, Lens Blur, Motion Blur, Radial Blur, Shape Blur, Smart Blur, and Surface Blur. Of these, Gaussian Blur is the most used, allowing you to create a smooth, all-over blur. This is perfect for hiding little wrinkles and imperfections—but a little goes a long way.

The Blur and Blur More filters also create an all-over blur, but they don't let you control the intensity. The Radial and Motion Blur filters are useful for creating special effects. Surface Blur softens areas of similar tone while trying to maintain sharp edges.

Distort Filters

The filters in the Distort menu add waves and other effects to images. The filters in this group are quite varied in their effects. The most interesting (and easy to use) of these are:

Diffuse Glow—Applies a misty glow to your image.

Glass—Adds shiny highlights and texture to your image. You can select from the look of frosted glass, glass blocks, etc.

Original image.

Gaussian Blur filter.

Radial Blur filter.

Surface Blur filter.

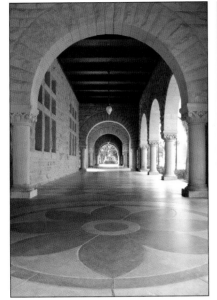

Original photograph.

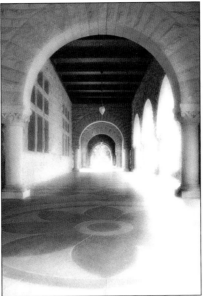

Diffuse Glow filter.

Glass filter (set to frosted).

Pinch filter.

Ripple filter.

Twirl filter.

Ocean Ripple, Ripple, Wave, Zigzag—Enhance your image with wave effects (each adjusted using slightly different sets of controls). The Zigzag filter offers a nice pond-ripple setting, for example. Applied to extremes, all create interesting abstracts.

Lens Correction—This useful filter is covered on pages 80–81.

Pinch—Makes the center of the image appear to be pinched in.

Spherize—Makes the center of the image appear to bulge out.

Polar Coordinates, Twirl—Twists your image either from the center or around an edge point.

TEXTURE AND STYLIZE

Next in our look at filters are the Texture and Stylize groups. The effects they create are very specialized, but they can be quite interesting when combined in sequence with other filters.

There are two more groups of filters for you to try before we move on to examine two specialized filters. As you've seen, filters are powerful tools, but moderation is definitely called for if you want to use them effectively.

Texture Filters

The Texture filters, as their name implies, add the look of a textured surface to your images. The Craquelure filter creates the look of crumbling plaster. The Grain filter, like the Film Grain and Noise filters, adds a speckled look. The Mosaic Tiles and Patchwork filters add a pattern of recessed-looking areas to the image, creating the impression that it is made up of tiles/patches. The Stained Glass filter divides the image into uniformly colored areas (cells)—it's one of the more realistic effects. Finally, the Texturizer filter let you add the texture of bricks, sandstone, canvas, and burlap. These filters can reduce fine detail. For best results, select images where the shapes of the subjects are more important than their existing texture.

Stylize Filters

The filters in this group can create some very interesting looks. You won't use them every day, but they are a lot of fun. The Diffuse filter puts soft edges on everything. The Emboss filter works like

Original photograph.

Stained Glass filter.

Craquelure filter.

Original photograph.

Diffuse Glow filter.

Glass filter (set to frosted).

Pinch filter.

Ripple filter.

Twirl filter.

Ocean Ripple, Ripple, Wave, Zigzag—Enhance your image with wave effects (each adjusted using slightly different sets of controls). The Zigzag filter offers a nice pond-ripple setting, for example. Applied to extremes, all create interesting abstracts.

Lens Correction—This useful filter is covered on pages 80–81.

Pinch—Makes the center of the image appear to be pinched in.

Spherize—Makes the center of the image appear to bulge out.

Polar Coordinates, Twirl—Twists your image either from the center or around an edge point.

PIXELATE AND RENDER

Sometimes the name of a filter doesn't tell the whole story. When you're experimenting with filters, be sure to try extreme settings (both high and low). What happens might pleasantly surprise you.

Like most of the sets of filters, there are some gems here, and some you'll never find the right picture for. Spend some time with the Lighting Effects filters, though—you'll discover some useful and interesting effects with the different settings.

Pixelate Filters

The Pixelate filters create a number of stylized effects. Essentially, these filters function by breaking the image into clumps—circles, squares, and other patterns. When using these filters, you should select a relatively low setting in the dialog box, or your image will become unrecognizable.

The Color Halftone and Mezzotint filters replicate the look of traditional printing techniques. The Mosaic, Fragment, Facet, and Crystallize filters break the image up into cells (geometric areas of a single color) of varying shapes. The size of the cell is set in the dialog box.

The Pointillize filter is probably the most useful one in this set, since it replicates the look of a traditional painting technique. In the style of a subgroup of the French Impressionists (called Pointillists), this filter renders the image as

Original photograph.

Mezzotint filter.

Pointillize filter.

Original photograph.

Difference Clouds filter.

Lens Flare filter.

Lighting Effects filter.

3D Transform—Allows you to "wrap" your picture over a virtual cylinder, cube, or sphere (in the dialog box, select the appropriate shape, then click and drag over the image preview). You can view your image from different perspectives using the pan and tilt features.

Clouds—Creates clouds based on the foreground and background colors. The on-screen image doesn't affect how they look.

Difference Clouds—Similar to the Clouds filter but incorporates data from the image on the screen. (Try applying this filter ten or more times sequentially to create a pattern that looks somewhat like marble.)

Lens Flare—Simulates the washed-out effect and geometric shapes created when bright light strikes a camera lens. Specify the center of the flare by clicking inside the image preview or dragging the crosshairs.

Lighting Effects—Allows you to apply a variety of light sources (from flashlights to spotlights) to your image. This is a slightly complicated filter to use. Begin by selecting a style (from the top pull-down menu). Then adjust the direction by clicking and dragging to rotate the light in the preview of your image. Other settings in the dialog box fine-tune the effect—the best way to learn to use these filters is simply to experiment!

Texture Fill—Fills a selection with all or part of a Grayscale file. To add texture, open the Grayscale document you want to use as the texture fill.

groups of tiny dots of color. As long as you keep the cell size small, your eye will blend these dots together into a unified image.

Render Filters

The render filters produce some special 3-D shapes, clouds, refraction patterns, and simulated light effects. These are mathematically intensive filters and may take a while to apply to your image, so be patient.

TEXTURE AND STYLIZE

Next in our look at filters are the Texture and Stylize groups. The effects they create are very specialized, but they can be quite interesting when combined in sequence with other filters.

There are two more groups of filters for you to try before we move on to examine two specialized filters. As you've seen, filters are powerful tools, but moderation is definitely called for if you want to use them effectively.

Texture Filters

The Texture filters, as their name implies, add the look of a textured surface to your images. The Craquelure filter creates the look of crumbling plaster. The Grain filter, like the Film Grain and Noise filters, adds a speckled look. The Mosaic Tiles and Patchwork filters add a pattern of recessed-looking areas to the image, creating the impression that it is made up of tiles/patches. The Stained Glass filter divides the image into uniformly colored areas (cells)—it's one of the more realistic effects. Finally, the Texturizer filter let you add the texture of bricks, sandstone, canvas, and burlap. These filters can reduce fine detail. For best results, select images where the shapes of the subjects are more important than their existing texture.

Stylize Filters

The filters in this group can create some very interesting looks. You won't use them every day, but they are a lot of fun. The Diffuse filter puts soft edges on everything. The Emboss filter works like

Original photograph.

Stained Glass filter.

Craquelure filter.

the Bas Relief filter (in the sketch group) but creates "edges" that reflect color. The Extrude filter creates a geometric 3-D look, while the Tiles filter creates a flatter patchwork look. The Find Edges, Glowing Edges, and Trace Contour filters trace the contours of the image with fine lines and can produce appealing results. The Solarize filter creates a stylized look based on a darkroom technique (usually this renders the image quite dark). The Wind filter makes it seem as if the colors are blowing off your photo.

Original photograph.

Find Edges filter.

Glowing Edges filter.

Extrude filter.

Wind filter.

Emboss filter.

COMBINING MULTIPLE FILTERS

Now that you know how to apply filters to your image, don't limit yourself to using only one filter at a time. Using two (or more) filters on your images can often produce truly unique results. There are almost limitless combinations of filters and settings. Here are few you can try:

- Begin with a color image. Run Rough Pastels, then Find Edges to create a strangely colored, crayon-drawn look.

- Begin with a color image. Run the Watercolor filter, then the Water Paper filter for a very textural look.

- Begin with a Grayscale image. Run the Find Edges filter, then follow it up with the Smudge Stick filter to create the look of a pencil sketch.

LIQUIFY

The Liquify filter can be used to change the shapes of your subjects. This can be done to subtly enhance their appearance, or to wildly change it—the choice is yours.

The Liquify filter (Filter>Liquify), allows you to freely twist, stretch, and warp an image. While warping may not sound like it would result in pleasant changes to an image, it's quite useful in retouching. As you can see below and on the facing page, selectively distorting small areas of an image can help to eliminate little figure flaws in portraits for a more flattering look. It can also be used to smooth out the little bulges that result from tighter clothing, like snug waistbands. In advertising photography,

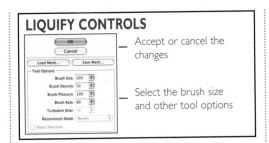

LIQUIFY CONTROLS

— Accept or cancel the changes

— Select the brush size and other tool options

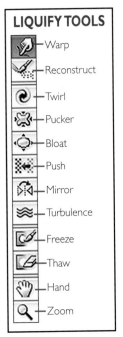

LIQUIFY TOOLS

- Warp
- Reconstruct
- Twirl
- Pucker
- Bloat
- Push
- Mirror
- Turbulence
- Freeze
- Thaw
- Hand
- Zoom

this tool is even used to make a model's eyes or lips look a little bigger or more full.

The key to using the tool for retouching is subtlety. The more you distort a given area, the more likely the

The Warp tool in the Liquify filter was used to slightly slim the woman's hip area for a more flattering look (far left, original; left, retouched). Original image courtesy of Jeff Smith.

Here, the man's chin and neck (left) were reshaped using the Liquify filter (center). Using the Burn tool, the shadows were then enhanced to further reduce the visibility of this area (right). Note that the change is subtle—people should still look like themselves after you make these little refinements. Original image courtesy of Jeff Smith.

refinement will look fake. When using it on people, be careful not to distort your subjects so much that they don't look like themselves.

To use this filter, go to Filter>Distort>Liquify. Doing so will open a full-screen dialog box with a large preview of your image in the center and two control panels on either side. To the left of your image are the tools, and to the right are the options.

To begin, select the Warp, Turbulence, Twist, Pucker, Bloat, Push, or Mirror tool. Then, choose a brush from the options panel. For the most impact, select a rather large brush (perhaps in the 50–100 range), and set the brush pressure to about 50 (higher settings will provide even more distortion). Then, by clicking and dragging over the image preview, simply begin painting on the distortion. The longer you leave your brush in one area, the more the pixels there will be distorted. Try experimenting with several of the tools, using different brush sizes and pressures, and painting quickly versus slowly.

If you like the results of your work as shown in the preview window, hit OK to accept the changes. If you don't like them but you want to try again, hit Revert.

Of course, the Liquify filter can also be used to create effects that are far from natural.

LENS CORRECTION

As you may recall, we've already looked at one way to remove the distortion that sometimes appears in images (see pages 30–31). This filter, however, streamlines the process to a greater degree.

The Lens Correction filter (Filter> Distort>Lens Correction) provides access to controls that allow you to quickly correct common perspective problems.

When you activate the filter, a full-screen dialog box appears with a large preview of your image. Superimposed over the image is a grid, which is helpful as a reference for squaring up your image. To change the size of the grid, simply adjust the Size box at the bottom of the window. In the pane to the right, you'll find a series of sliders. The following are the options, from top to bottom.

Remove Distortion

This slider compensates for effects that cause lines near the edge of the photo to bow out (often with wide-angle lenses) or in (often with telephoto lenses).

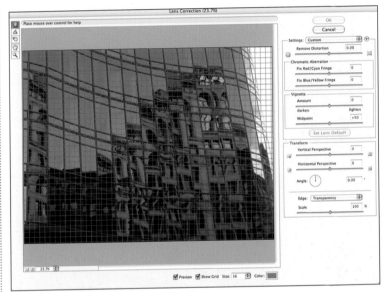

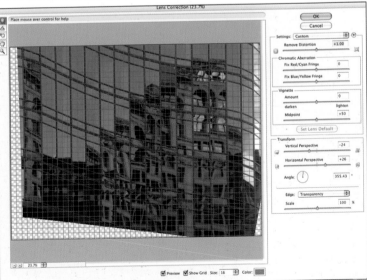

Selecting the Lens Correction filter (left) opens a full-screen dialog box (top). Using the sliders (above), you can adjust your image until the vertical and horizontal lines in the photo match up with the superimposed grid lines. When you're done, just hit OK to apply the changes.

Chromatic Aberration

Here, you adjust for the slight prismatic effect of some lenses that produces halos around edges that should be sharp.

Vignette

This slider lets you compensate for the darkened edges that sometimes appear when using a wide-angle lens at a wide

When you accept the changes in the Lens Correction dialog box, your image probably won't have square edges anymore (left). To correct this, flatten the image (Layer>Flatten Image), then crop it to the desired shape (below).

aperture (or you can use this slider to *add* a vignette for creative effect).

Transform

This tool lets you scale the vertical and horizontal perspective of your image to compensate for the distortion that occurs when the camera's lens is not square with the subject.

Finishing Up

When you hit OK to accept the changes you've made, you'll probably be left with an image that isn't square at the edges. To correct this, just flatten the image (Layer>Flatten Image) and use the Crop tool to restore a rectilinear shape to the image.

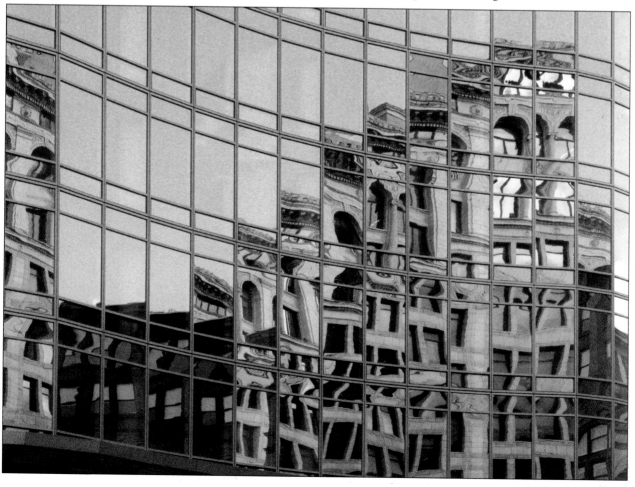

STYLES

Snakeskin! Ancient Stone! Double Green Slime! Okay, these may not be things you'll use every day, but you have to admit it's tempting. The Styles palette has more practical tools as well, though, so read on.

The Styles in Photoshop work a lot like the filters, but they are significantly more complicated and often involve several steps. Fortunately, everything is totally automated.

To apply a style, you'll first need to duplicate your background layer. We'll discuss layers in detail in the next chapter. For now, though, all you need to do is open an image and go to Layer> Duplicate Layer. Then, hit OK in the dialog box that appears.

Once this is done, open the Styles palette (Window>Styles). To apply a style, all you have to do is click on its icon. If you click on another style, it will automatically replace the first style, so it's easy to try out a number of styles very quickly.

Only a few of the available styles are loaded when you install Photoshop. To load the rest, click on the black triangle button at the top right of the palette and select Load Styles. In the Load dialog box that appears, select all of the ".asl" files and click on load. The complete selection of styles will then appear in your Styles palette.

From the same menu at the top right of the palette you can also select to view the styles as a list, as thumbnails, or as text only (by style name).

The Styles palette with the Large List view selected from the fly-out menu (opened from the black triangle button at the top right of the palette).

Original photograph.

Batik style.

Fog style.

Night Vision style.

Puzzle style.

Rain style.

Red Paper Clip style.

Overlay with Gold style.

Duotone with Texture style.

Negative style.

Working with Layers

Master the use of layers and you'll have a brand-new world of imaging options. The more you practice with these, the more intuitive they become, so don't get frustrated— this is a challenging topic!

THE BASICS OF LAYERS

Layers are one of the most versatile tools in Photoshop, making digital imaging even more foolproof. Hate the effect you used? Throw away the layer and start over!

Layers are like sheets of clear plastic, laid one on top of the other. Each layer can be accessed, worked on, moved, or deleted independently of any other layer. This is great for trying out effects, since you can simply discard the layer if you don't like the results.

Layers Palette

Layers can be created, accessed, and manipulated via the Layers palette. If this is not visible on your screen, go to Window>Layers. As you can see in the diagram on the facing page, many features connected with the use of layers can be accessed directly from this palette. Other features for using layers are accessed via the Layer pull-down menu at the top of the screen.

The main feature in the Layers palette is the list of layers. These are stacked from bottom to top. The background layer (usually the photograph you opened or a new image you're going to add to) is the bottom layer. The layers that overlay it rise one after another to the top of the palette (the top layer in the image).

While the background layer must remain in the background, you can re-organize the other layers as you like by clicking on the layer (usually to the right of its name) and dragging it into a new position on the list.

Making Layers

When you open an image or create a new image, you'll see only one layer: the background layer. You can create as many layers as you like, but additional layers take up more memory. Therefore, you'll need more storage space, and more time to open the image or to perform operations on it.

To create a new, empty layer, go to Layer>New>Layer. Alternately, from the upper-right corner of the Layers palette, use the fly-out menu (from the black arrow button) and select New Layer. Doing so will cause a dialog box (as seen below) to appear. At the top of this is a blank field in which you can type a name for your new layer. If you don't want to name it yourself, Photoshop will label the new layers sequentially (Layer 1, Layer 2, etc.). The uses for the other settings will be discussed later in this chapter.

New Layer		
Name: Layer 1		OK
☐ Use Previous Layer to Create Clipping Mask		Cancel
Color: ☐None		
Mode: Normal	Opacity: 100 %	
☐ (No neutral color exists for Normal mode.)		

New Layer dialog box.

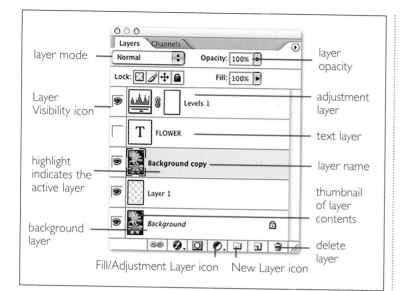

layer mode

Layer Visibility icon

highlight indicates the active layer

background layer

layer opacity

adjustment layer

text layer

layer name

thumbnail of layer contents

delete layer

Fill/Adjustment Layer icon New Layer icon

Alternately, you can click on the New Layer icon at the bottom of the palette. A new layer will be created and numbered for you. Its mode will be set to Normal and its opacity will be 100 percent (see pages 86–87).

Often, you may want to duplicate an existing layer. To do this, go to the Layers palette and drag the existing layer onto the New Layer icon. Open an image and try this with your background layer. Duplicating the background layer is often a good first step when working on an image. By doing this, you preserve a handy copy of the original image to refer back to.

You can also create a new layer by dragging in a layer from another image. To do this, open two images and position them so both are at least partially visible on the screen. Choose the Move tool (see page 13), then click on one image and drag it over the other image.

Another way to create a new layer is to select some or all of an image (see chapter 8), then copy (Edit>Copy) and paste (Edit>Paste) it. The pasted area will automatically appear in a new layer.

Removing Layers

To delete a layer, drag it into the trash can at the bottom of the palette. This will remove the layer and any data on it.

To get rid of all of your layers while preserving the data on them, go to Layer>Flatten Image. This will composite all of the layers down into one unit—preserving everything you've added.

To composite one layer with the layer directly below it, select the layer to be composited, then go to Layer>Merge Down.

To composite some (not all) of your layers, make invisible (click the eyeball icon off) the ones you want to preserve. Then, click on a visible layer to activate it and go to Layer>Merge Visible.

Saving Files with Layers

Because digital images are so malleable, you may find that you want to return to an image several times to make creative improvements or other adjustments. This makes it a good idea to save a working copy of your image *before* you do any flattening or merging of layers. By preserving the layers, you'll ensure the widest range of editing options.

To save your file with the layers intact go to File>Save As. Then, select the Photoshop (PSD) file format from the pull-down menu, name your image, and hit OK.

For many applications (like saving the file as a JPEG to use on a web site or as an e-mail attachment), you cannot have layers in your file. In these cases, you can simply save a copy of the image with layers (as a PSD), then flatten it and save a second copy in the desired format.

MORE ABOUT LAYERS

This is where layers start to get really versatile—when you begin to control how they interact with each other. Set up an image as described below and give these layer settings a try.

To begin playing with some layer settings, you'll need to create an image with layers. To get started, open two images and drag one into the other as described on the previous page. Don't worry if they aren't the same size or look weird together—this is just for practice!

Layer Modes

The layer modes are a predetermined set of instructions for how the layers should interact with each other. To experiment with the layer modes, activate any layer (other than the background layer) with image data on it. Then, use the pull-down menu at the top of the Layers palette to switch the mode of this layer. On the next page is an overview of the differences between modes; this is just for reference. What's important is to get a feel for the looks you can create.

Layer Opacity

A layer's opacity determines how transparent it is (how much of the underlying

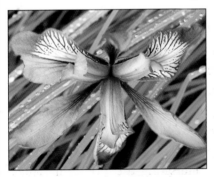
Flower overlays leaf on separate layer.

Flower layer set to 75-percent opacity.

Flower layer set to 35-percent opacity.

Flower layer set to Vivid Light mode.

Flower layer set to Exclusion mode.

Flower layer set to Linear Burn mode.

layer will be visible through it). To adjust the opacity, click on an overlying layer (not the background) to activate it. Then, at the top of the palette, set the opacity as you like. At 0 percent the layer will be invisible; at 100 percent it will be opaque.

LAYER MODES: AN OVERVIEW

Normal—No change takes place.

Dissolve—Pixels scatter based on their transparency.

Multiply—The mathematical value of the top layer is multiplied with that of the bottom layer(s).

Screen—The mathematical value of the top layer is added to that of the bottom layer(s).

Overlay—Light areas in the top layer are "screened" (see above); dark layers are "multiplied" (see above).

Soft Light—Based on the overlying layer, treats black as burning and white as dodging (see pages 110–11).

Hard Light—Very similar to the Overlay mode.

Color Dodge—Similar to both Screen and Lighten, tends to lighten images.

Color Burn—Like Color Dodge, but darkens images.

Darken—Chooses the darkest values of the affected pixels.

Lighten—Chooses the lightest values of the affected pixels.

Difference—Displays the difference between the top and bottom pixels based on their hue and brightness.

Exclusion—Inverts colors in the underlying area based on the lighter areas in the layer above.

Hue—Alters the color of the layer without affecting the brightness or saturation.

Saturation—Saturation of upper layer replaces that of lower level.

Color—Colors of upper layer replace colors of lower layer, while brightness remains constant.

Luminosity—Retains underlying layer's color and saturation while basing brightness on the upper layer.

Grouping Layers

Often, it's helpful to group layers together. Imagine that (for some reason) you have your subject's body on one layer and her head on another. They are perfectly lined up, but now you want to move them both three inches to the left. You could move them individually and realign them, or—better yet—you could group them. Then, when you move the head, the body will always come along with it (as well it should!).

To group two (or more) layers, choose one of the layers and click on it to activate it. Then, press and hold Shift while clicking on each layer to be grouped with the one you selected. When all the layers are active, click on the chain icon at the bottom of the palette. A chain will appear next to each layer name, indicating the layer is grouped. To ungroup the layers, click on the chain again.

Make Visible/Invisible

When you want to work on a layer without being distracted by image elements on other layers, simply make those layers temporarily invisible. To do so, click on the Layer Visibility icon (see page 85). Doing so will make the eyeball icon disappear, indicating the layer is invisible. To make it visible again, click the Layer Visibility box again. This is really helpful when the area you want to work on is partially obscured by image elements on a layer above it.

Or, if you're trying to decide between two options for an image, you can execute each option on a separate layer, then switch them on alternately to decide which one looks best.

LAYER STYLES

Layer styles help your layers stand out from each other, creating a sense of depth. This can help you add a nifty three-dimensional feel to your images.

Sometimes you don't want your layers to blend seamlessly with each other—you may even want them to look very much separate. The layer styles will help you create visual definition and add a sense of depth.

To do this, begin with an image that has two or more layers (layer styles cannot be created on a background layer). In the example shown here, a city scene was used as the background and pictures of buildings were added. (*Hint:* The image on the layer where you create the effect should have some free edges [not fill the entire layer edge to edge].)

To apply a layer style, activate the layer to which you want to apply the style, then go to Layer>Style and select an effect from the pull-down menu.

If you want to modify a layer style, you can access its settings from the layer by double clicking on the "*f*" near the right end of the layer in the Layers palette. If you want to remove a layer style, click on the arrow just to the right of the "*f*" to reveal the applied styles (see step 6, facing page), then drag the one you no longer want into the trash can (bottom of the palette).

The effects of layer styles vary widely, so experiment with them and keep them in mind for future projects!

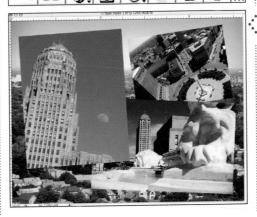

I Begin by opening the image you want to use in the background (or if you want a plain background, open a new document with a white background).

2 Open one or more additional photos. Click on each image with the Move tool and drag it into the document with the background image. This will create an image with several layers.

3 Click on an overlying layer in the Layers palette, then go to Edit>Transform>Scale or Edit>Transform> Rotate to change its angle and size. Use the Move tool to reposition it. Repeat on additional layers as needed.

4 Open the Layer Style menu from the Layer pull-down menu and select an effect from the list that appears.

Layer
New	▶
Duplicate Layer...	
Delete	▶
Layer Properties...	
Layer Style	▶
New Fill Layer	▶
New Adjustment Layer	▶
Change Layer Content	▶
Layer Content Options...	
Layer Mask	▶
Vector Mask	▶
Create Clipping Mask	⌥⌘G
Smart Objects	▶
Type	▶
Rasterize	▶
New Layer Based Slice	
Group Layers	⌘G
Ungroup Layers	⇧⌘G
Hide Layers	
Arrange	▶
Align Layers To Selection	▶
Distribute	▶
Lock All Layers in Group...	
Link Layers	
Select Linked Layers	
Merge Down	⌘E
Merge Visible	⇧⌘E
Flatten Image	
Matting	▶

Layer Style ▶ submenu:
Blending Options...
✓ Drop Shadow...
Inner Shadow...
Outer Glow...
Inner Glow...
Bevel and Emboss...
Satin...
Color Overlay...
Gradient Overlay...
Pattern Overlay...
Stroke...
Copy Layer Style
Paste Layer Style
Clear Layer Style
Global Light...
Create Layer
Hide All Effects
Scale Effects...

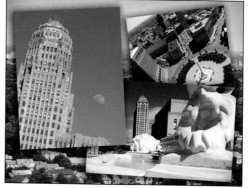

Image with Drop Shadow layer style.

Image with Outer Glow layer style.

5 In the dialog box that appears, adjust the sliders until you like the effect. You can add multiple effects to a layer from among the different sets of effects on the left side of the window.

Layer Style dialog box:
Styles
Blending Options: Default
☑ Drop Shadow
☐ Inner Shadow
☐ Outer Glow
☐ Inner Glow
☐ Bevel and Emboss
☐ Contour
☐ Texture
☐ Satin
☐ Color Overlay
☐ Gradient Overlay
☐ Pattern Overlay
☐ Stroke

Drop Shadow
Structure
Blend Mode: Multiply
Opacity: 75 %
Angle: 30 ° ☑ Use Global Light
Distance: 5 px
Spread: 0 %
Size: 5 px
Quality
Contour: ☐ Anti-aliased
Noise: 0 %
☑ Layer Knocks Out Drop Shadow

OK
Cancel
New Style...
☑ Preview

6 Once you have applied a layer style to a layer, you will see an "*f*" in a black circle to the right of the layer's name in the Layers palette. Clicking on this will reopen the dialog box shown in step 5. Clicking on the arrow next to it toggles open a list of the styles applied to the layer. Click the eyeball icon to make these visible or invisible.

Image with Bevel and Emboss layer style.

Layers palette:
Layers / Channels
Normal
Opacity: 100%
Lock: ☐ ☐ ☐ ☐ Fill: 100%
👁 Layer 3
👁 Layer 2
👁 Layer 1
 👁 Effects
 👁 Drop Shadow
👁 Background

Image with Drop Shadow and Stroke layer styles.

SPECIAL TYPES OF LAYERS

Because they allow you to execute some common tools on discrete layers (instead of on the image itself), fill and adjustment layers give you an added degree of control when correcting and enhancing color.

When you've applied color corrections so far, it's been to the image itself. With fill and adjustment layers, you have more options—and that's always a good thing.

Adjustment Layers

Adjustment layers are essentially hybrids, combining the features of layers with the functions of the Levels, Curves, Brightness/Contrast, and other color correction tools. There are several important advantages to using these tools on an adjustment layer. First, because the effects are seen on the image but contained on a discrete layer, you can toss the offending layer in the trash if it doesn't look right. Second, because the effect is on a layer, you can reduce the opacity of the layer to reduce the impact of the change—a great way to really finesse your image. Third, you can also change the layer mode of the adjustment layer to make it blend with the underlying layer in useful ways. Finally, you can access the tool's settings on this layer again and again—they don't zero out or return to the default settings when you hit OK.

To create a new adjustment layer, identify the layer you want to modify by activating it in the Layers palette.

1 Open any photograph that needs to have some color or tonal correction work done.

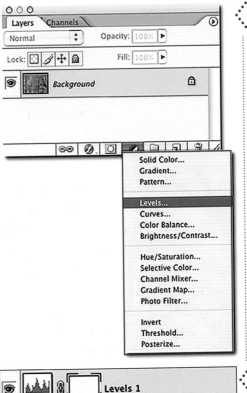

2 Click on the Adjustment Layer icon at the bottom of the Layers palette and select the tool you want to use.

3 In this case, the Levels were selected. This opened the Levels dialog box and created a new adjustment layer with an image thumbnail that looks like that dialog box.

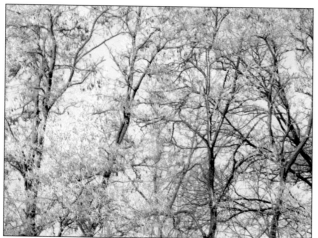

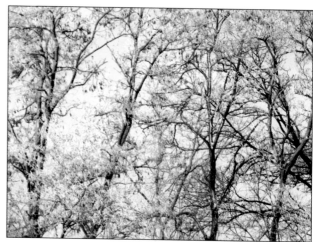

4 After adjusting the Levels as described on pages 56–57, the contrast was better (above left). However, the color still seemed a little off—something wasn't quite right.

5 To correct this, a few different layer mode settings were tried (see page 86). The Overlay mode looked best. To soften the effect slightly, the opacity of the adjustment layer was reduced to 80 percent (above right).

Then, go to Layer>New Adjustment Layer and select the tool you want to use from the menu. Next, you will see the New Layer dialog box (see page 84). Enter the settings you want (you can change them later in the Layers palette) and hit OK. Then, the dialog box (if any) for the selected tool will open. These work as described in the previous sections on individual tools.

To skip the New Layer dialog box, go to the Adjustment Layer icon at the bottom of the Layers palette. Clicking on this reveals a pull-down menu. Select the tool you want from this menu, and the dialog box (if any) for the tool will open up.

In the Layers palette, adjustment layers look rather unique. On the left is a layer thumbnail with a graphic representation of the tool used on that layer. If you decide you want to change the values you entered in the dialog box for the tool, simply double click on its icon in the layer. This will reopen the box so you can adjust the settings.

To the right of the layer thumbnail is the layer mask. This allows you to define areas where you *do not* want to apply the change on the layer. To do

this, click on the layer mask icon, then select a brush and paint on the image in black, "masking" these areas. As you do so, the change included on the adjustment layer will be eliminated from the masked areas. To unmask an area (restoring the effect), paint over it with white. (See pages 100–101 for instructions on painting.)

Fill Layers

To create a new fill layer, you do exactly the same thing, but you can select from three options: Solid Color, Pattern, or Gradient. If you pick Solid Color, the Color Picker will appear, and you can select the one color you want the layer filled with (for more on using the Color Picker, see pages 100–101).

If you pick Pattern, the Pattern Fill dialog box will appear. You can select a pattern from the ones that come with Photoshop or create and save your own custom patterns (see page 103).

If you pick Gradient, the Gradient Fill dialog box will appear. From the Gradient menu in this box you can select one of Photoshop's preloaded gradients. (For information on creating your own gradient, see page 103.)

Making Selections

Thought you had powerful control over your images with the tools presented so far? Surprise! When you master selections, you can start to make the precise changes needed to really perfect your images.

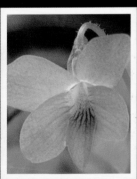

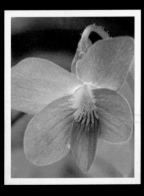

BASICS AND TOOLS

Selections are all about localized control—changing just the part of the image that needs work, or making totally different changes to different parts of the image.

So far, the techniques discussed have been applied to your entire image. The selection tools allow you to isolate individual areas that need work and apply your changes to only those areas.

When using selection tools, the areas you have selected are indicated by a flashing dotted black & white line (often called "marching ants") around the area. Making this line fall exactly where you want it to is the key to making accurate selections.

The selection tools also have unique Options bars (see page 13) that allow them to be customized for each task. As we begin to use these tools individually, you will learn how to adjust the options and how the versatility of each tool improves your ability to work with images.

Note: Once you have made a selection, *do not* click anywhere else on your image with a selection tool unless you want to deactivate (eliminate) your selection. If you accidentally do this, go to Edit>Step Backward or use the History palette to undo it.

Select All

The simplest way to make a selection (of your whole image) is to go to Select> All. Try this just to see what the selection indicator looks like.

Marquee Tool

The Marquee tool (see page 13) is used to make rectangular or elliptical selections. In the Toolbox, click and hold on the Marquee tool icon to make these options visible. Choose the tool that best matches the area you want to select, then click and drag over the desired image area to select it. You'll probably need to practice this in order to end up with the selection exactly where you want it in your image. This is especially true with the Elliptical Marquee tool, which can be tricky to master. (Instead of drawing the shape from its edge, it may help to draw it from the center by holding down the Alt/Opt key before you click and drag.)

To select a perfectly square or perfectly round area, select the Marquee tool (either rectangular or elliptical), press the Shift key, then click and drag over your image.

To make a selection of a fixed size, go to the Options bar and make the appropriate selection from the Style menu. Then, enter the measurements you desire in the boxes next to this menu. Also in the Options bar, note the Feather setting. This controls how sharp the edges of your selection will be. The higher the number, the more soft or

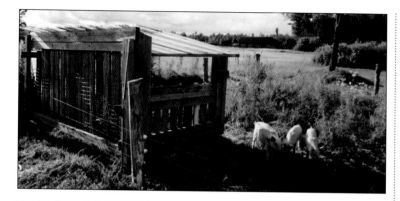

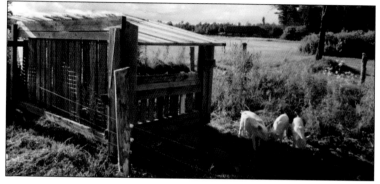

Using the Lasso tool, the pigs were selected. Then their color was adjusted to make them blue—without changing anything else in the image.

curved areas. To use it, select the Lasso tool, click on one edge of the area to be selected, then drag your cursor around the perimeter of that area.

The Polygonal Lasso tool lets you create geometric selections. To do this, select the tool, then click on one corner of the area to be selected. Release the mouse button, move the cursor to the next corner, and click the mouse. Repeat until the entire shape is selected.

The Magnetic Lasso tool is similar to the regular Lasso, but it tries to help you make more accurate selections by automatically "sticking" to lines in the image. To use it, select the Magnetic Lasso tool, click on one edge of the area to be selected, then drag your cursor around the perimeter of the area to be selected.

Specialized settings in the Options bar are used to control what the Lasso "sticks" to. Lasso Width controls how important the detected edge is versus the actual path of your mouse. Frequency controls how smooth you are able to make curves. Edge Contrast tells Photoshop how to decide what's a line and what's not. Be prepared—this takes a good deal of practice to master.

blurry the edges will be (although this isn't visible until you start editing the selected area).

Lasso Tool

The Lasso has three variations: Lasso, Polygonal Lasso, and Magnetic Lasso.

The Lasso tool is used to draw around an irregularly shaped area using a continuous line. This line can be made up of any combination of straight and

TIPS

MARQUEE TOOL

• To reposition a selection after you have released the mouse button, select the Marquee tool, then click and hold within the selected area and drag the selection into place.

• To deactivate a selection, click outside the selection with the Marquee tool.

LASSO TOOL

• You must end the selection where you began it (make a closed shape).

• To draw a perfectly straight horizontal or vertical line, press and hold the Shift key while you are tracing the edge of your selection.

MORE SELECTION TOOLS

Don't think about the selection tools in isolation. To make the most accurate selections (which yield the best-looking results), you'll almost always need to use more than one tool.

The selection tools discussed in the previous chapter allowed you to make your selections geometrically or by drawing them onto the image. The following tools offer a different approach that often works well in concert with the previously discussed tools.

Magic Wand

The Magic Wand is a selection tool that is used to select areas based on their color. It is very useful when you need to select an irregularly shaped area with little or no tonal variations (like the blue areas in a sky with scattered clouds).

To use it, choose the Magic Wand from the Toolbox (see page 13). Identify the area to be selected. Click on one point in that area. The Magic Wand will automatically select that point and all other contiguous points of the same color. (To select *all* points of the same color in the *entire* image, deactivate the Contiguous setting in the Options bar.)

For the Magic Wand, the most important options setting is Tolerance. By setting the Tolerance, you can define how picky Photoshop will be in defining what colors are "the same" as the one you indicated (and, therefore, what will be included in the selection). The larger the number you enter, the more liberal

its definition will be. A good place to start is at about 30. Often, you'll need to experiment to determine the best value. To do this, enter a value and click on the area you want to select. If you want to expand the area, enter a larger value, then click on the area again. If you want to reduce the area, enter a smaller value and click on the area again. Repeat this process as needed to find the value that produces the best results for the selection you want to make.

Masks

Many people find masks confusing, but they are just a different way of making a selection. Masks in Photoshop are used to cover areas that you don't want to change. Therefore, to apply a mask, you

The Magic Wand tool was used to select the orange area on the butterfly's wings. Because it was not set to Contiguous, all of the image areas with the chosen orange color were selected.

paint over the area of the image that you *don't* want to select. For that reason, it's a good option when you want to select all but a small area of an image.

After switching over to the Quick Mask mode (see page 13), select the Brush tool. In the Options bar, you can then choose a larger or smaller brush size and select the hardness of the brush. (The harder the brush, the more crisp the edges of the selection will appear. For more on this, see page 101.)

Additionally, you can set the Overlay Color. This is the color that you will paint the mask with and is set to red by default. The Overlay Opacity lets you control how much of your image shows through the mask.

Painting bright red brush strokes onto your image may seem scary, but don't worry—they disappear and leave a standard selection indicator around the unpainted area when you return to the standard editing mode (see page 13).

Select a Color Range

When you go to Select>Color Range, you'll find another way to select parts of an image based on the their colors. In the dialog box that appears, you'll find a series of eyedroppers. Use these to click on the color in your image you want to select. This area will then become white in the image preview in the dialog box. To enlarge the selection, choose the plus eyedropper and click on another color. To reduce the selection, choose the minus eyedropper and click on another color. When you're done, hit OK to close the dialog box. The selection you made will appear on your image.

1 To make a mask, select an image where you want to change all but a small part. Here, let's say we want to change all of the leaves but not the flower.

2 Switch to Quick Mask mode and choose the Brush tool. Then, paint over the flower to mask it. If you make a mistake, use the Eraser tool to restore any area you didn't want masked.

3 When you're done, swtich back to standard mode to turn the mask into a Selection. If you need to edit the selection further, return to the Quick Mask mode.

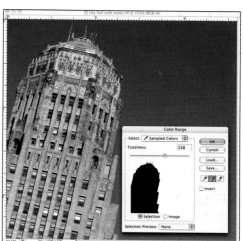

In the Color Range dialog box, you use eyedroppers to click on the colors you want to select. Here, the blue sky was selected.

MODIFYING SELECTIONS

Once you have a selection made, are you stuck with it? No way! You can add to it, subtract from it, expand it, smooth it—and do a lot of other things to make it precisely the way you want it.

In addition to helping us when we can't trace the perfect shape with our mouse, modifying selections helps us be strategic about making selections.

Adding/Subtracting

To add to a selection (include more image within it), choose a selection tool. In the Options bar, click on the Add to Selection icon. A "+" will appear next to your cursor, indicating that you are now adding to the selection. (Pressing and holding the Shift key will also set the tool to add to a selection.) Use the tool to select the area you want to add. It's okay if the new area overlaps the previously selected areas; the overlaps will be combined in the new selection.

To subtract from a selection (cut from the existing selection), choose a selection tool and click on the Subtract from Selection icon. A "–" will appear next to your cursor, indicating that you are subtracting from the selection. Select the area you want to remove from your selection. (Pressing and holding the Opt/Alt key will also set the tool to subtract from a selection.)

Inversing

Inversing a selection (Select>Inverse) selects all of the areas that are *not* in the

New Selection (default setting) Add to Selection Intersect Selection Subtract from Selection

current selection. This is a useful tool in two common situations.

First, imagine a portrait that needs only small color corrections—except for the subject's shirt, which should be a totally different color. You can select the shirt, change the color, then inverse the selection and make the other changes.

Second, in some instances it is easier to select the material you *don't* want to select, then inverse the selection to include the areas you *do* want. For example, when you want to select a subject who was photographed against a solid background, you can use the

SAVING AND LOADING

Making complicated selections takes some time—especially when you are new to the process. When you have finished making one, you can save it by going to Selection>Save Selection. In the dialog box that appears, name your selection and make sure New Selection is chosen. Then hit the OK button. If you need to reuse the selection, just go to Selection>Load Selection and choose the selection you named from the pull-down menu at the top of the dialog box that appears.

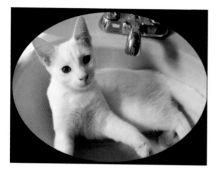

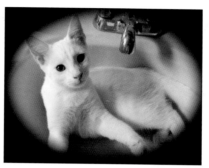

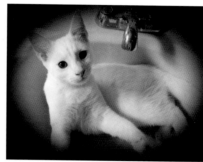

1 To vignette an image (darken the corners and edges), the Marquee tool was used to select an oval in the center of the image. The selection was then inversed to select the areas outside this oval. Going to Edit>Fill, the selected area was filled with black (left). For more on the Fill command, see page 102. Original image by Barbara Lynch-Johnt.

2 The edges of the vignette looked hard, so the History palette was used to undo the fill, and the selection was feathered 50 pixels (center) before reapplying the fill.

3 Step two was repeated, but the selection was feathered 100 pixels to make the vignette even softer (right).

Magic Wand to select the solid background, then inverse the selection to select the subject instead.

Feathering

When using the selection tools, you may notice that the edges of the selected area are very hard and abrupt. In photos, this can make the edges of your selection look unnatural—as though they were cut with a pair of scissors. Feathering a selection allows you to slightly (or dramatically) blur the edges of the selected area, creating a smoother look.

To feather an active selection, just go to Select>Feather and enter the desired value in the dialog box that appears. The higher the value, the blurrier the edges of the selection. Deciding exactly what number to enter will take some experimentation. In general, 2 pixels will create an edge that is barely blurred—just enough to create a smooth transition, but not enough to be noticeable to the viewer.

Select>Modify

With a selection made (and still active with the dotted black & white line surrounding it), go to Select>Modify and choose the option you want (Border, Expand, Contract, or Smooth). In the dialog box that appears, select the degree of change by entering a number

of pixels (the higher the number, the greater the change). Experimenting with the settings will give you a good idea of what to anticipate. Smoothing a selection by one or two pixels can be particularly useful—especially if you don't have a perfectly steady hand when using the Lasso tool.

Grow

The Grow command allows you to increase an already selected area. It does this by causing the selection to include similar tones in contiguous areas. To apply the Grow command to an active selection, go to Select>Grow. The selection will grow automatically. You can do this repeatedly to make your selection grow incrementally larger.

Similar

The Similar command also allows you to add to your selection. Rather than adding similar contiguous tones, the Similar command seeks out similar tones throughout the image and adds them to your selection. To use the Similar command on an active selection, go to Select>Similar. The selection will grow automatically.

WORKING WITH SELECTIONS

Okay, you've made some selections. Now what? Well, this is where things start to get really interesting—where you start being able to exercise complete control over even the minute details of your image.

If you're like most photographers, you don't shoot a lot of *absolutely perfect* images. Most of us take a lot of *good* pictures—pictures we'd like a lot more if we could fix just one or two little things.

When you start working with selections, you can isolate the changes you make—meaning you can adjust only the parts of the image that bother you and leave the rest alone.

The following are some common operations using selections. These employ some of the techniques you know how to use already and some you'll be learning in the next two chapters.

Distracting Backgrounds

Who doesn't have a bunch of family photos like this sitting around? We keep them because the subject looks good, but don't frame them because, well, nothing else really does.

To eliminate background problems, select the background (using whatever selection tools you want), then make whatever adjustments you decide are needed to improve the situation. This could include applying filters, using the Brightness/Contrast command to darken the area, applying the Clone Stamp tool to stamp out problem areas (see

1 Here's a cute shot . . . but it sure would be nice if the background wasn't so distracting!

2 The background was selected using the Lasso tool. The Gaussian Blur filter was used on the selected area and its contrast and brightness were reduced.

3 Blurring helped, but not quite enough. Therefore, the Clone Stamp tool was used to eliminate the remaining distractions. This really lets you focus on the cute expression.

 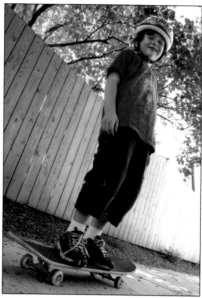 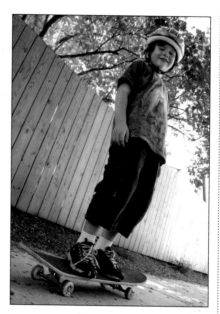

Using a selection made with the Magic Wand tool, the boy's t-shirt (left) was isolated from the rest of the image. This allowed it to be changed to any other color (center and right) without affecting any of the other areas of the image.

pages 106–7), etc. But whatever tool you want to use, you won't have to worry about messing up the subjects; the selection will constrain your changes to the background.

Changing Colors

On page 40 we looked at the Hue/Saturation command, which can be used to change one color to another. By itself, this is very effective if the color you want to change appears nowhere other than where you want to change it. What happens, though, when you want to change a green dress to a red dress, but

you don't want the green grass to change color at the same time? The answer (as you have probably already guessed) is that you make a selection.

Once you've selected the area where you want to change the color, you can use whatever tool or command you want to execute the change—and it will only affect the selected area.

Compositing Images

Imagine you have two almost identical pictures of your friend Susan. In one, Susan is posed in a very flattering way—but she blinked during the exposure! In the other, her eyes are open and she's showing her great smile—but she put her hand in her pocket and it doesn't look as good.

To fix the problem and create one great image, you could select the head from the image where her face looks great, copy the selected area, then paste it into the image where the pose is great.

This technique is called compositing, and it is covered in detail on pages 116–17.

SELECTION TIPS

- To automatically create a new layer, make a selection, then go to Edit>Cut or Edit>Copy (cutting removes the area, copying duplicates it). Then, go to Edit>Paste. The material you paste will reappear on a new layer.

- When you are done with a particular selection, you can deselect it by clicking outside it with the Marquee tool or go to Select> Deselect. To reactivate your latest selection, simply go to Select>Reselect.

Adding Artwork

Ready to get a little creative? Try adding some original artwork to your photograph or designing a whole new image on a blank canvas. Your imagination is the only limit.

COLORS AND BRUSHES

As any good artist knows, the first step to creating artwork is knowing your tools—and Photoshop puts a great artistic tool kit right at your fingertips.

Many of the tools in Photoshop are used for painting, airbrushing, drawing, etc. When using these tools, you need to be able to specify the color of paint that you want to use. There are several ways to do this.

In Photoshop, you can keep your "brushes" loaded with two colors—the foreground and background colors. Swatches of the current setting for each color appear at the bottom of the Toolbox (below).

The foreground color is the color actively available for painting or drawing. When you open Photoshop, the foreground color will be set to black, and the background color will be set to white. However, these can be changed and set as you like.

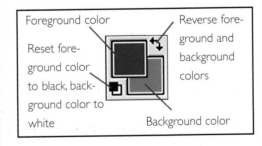

Foreground color

Reset foreground color to black, background color to white

Reverse foreground and background colors

Background color

Swatches

The easiest way to change the foreground color is to use the preset colors provided in the Swatches palette (Window>Swatches).

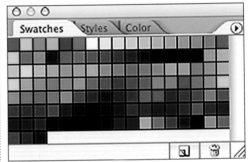

The Swatches palette.

To set one of these colors as your foreground color, simpy click on the square with the color you like. To use a color from the swatches as your background color, hold down the ⌘/Cmd key and click on a swatch.

Color Picker

To create a custom color, use the Color Picker. To open it, click once on either the foreground or background color swatch in the Toolbox.

In the Color Picker dialog box, you will see a large window with shades of a single color. To the right is a narrow bar with the full spectrum of colors. At the top right are two swatches; at the top is the current color, and at the bottom is the original color. At the bottom right are the numerical "recipes" for the selected color (see pages 44–45).

To use the Color Picker, begin with the narrow bar that runs through the

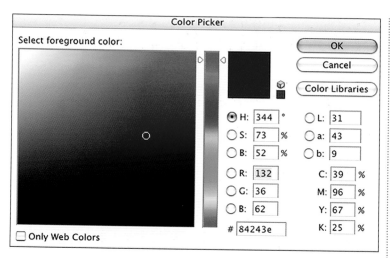

The Color Picker dialog box.

Brushes

When you select a painting tool (see next page), the Options bar changes to include brush size and shape. You can also set the opacity (how transparent the paint you apply will be) and the mode of the paint (identical in name and function to the layer modes—see page 86).

To select one of the many preset brushes, click on the rectangular box with the brush stroke in it in the Options bar. At the top of the window that pops open, you can select from different types of brushes and see samples of them in the window below.

To adjust the size of the brush, simply move the Master Diameter slider to the left (smaller) or right (bigger).

To adjust the hardness of the brush (how sharp the edges are), move the Hardness slider.

colors of the rainbow. Click and drag either of the sliders on the bar up and down until you see something close to the color you want in the large window. Then, in that large window, move your cursor over the color you want and click to select it. Hit OK to apply the change.

To select a second color, use the bent arrow above the color swatches in the Toolbox to reverse the foreground and background colors. This will swap your first color into the background so you can pick a new foreground color. Reverse these as often as you want.

Part of the Options bar for the Brush tool.

To adjust the mode or opacity of the paint, continue to move to the right on the Options bar and set each one as you like.

When you're done, just click and drag over your image to begin painting with the foreground color and brush you chose.

MORE ON BRUSHES

• We looked at one use for the Eyedropper tool on pages 46–47, but you can also use it to select a color from your image for use as the foreground color. Just choose the Eyedropper and click on the desired color.

• Some additional brush options can be set in the Preferences dialog box (Photoshop>Preferences>Display & Cursors [Mac] or Edit>Preferences>Display & Cursors [Win]). Under Painting Cursors, you can select different ways for your brush to appear on screen. As you click on the various settings, watch the cursor style change in the preview box at the top of the window.

PAINTING AND FILLING

Painting and filling let you customize your images in ways that were impossible before digital imaging. Play with these tools for a while and you're sure to find uses for them in a number of your images.

The painting tools have similar options but specialized functions, as described below. The fill tools are used to cover large areas or to fill selected areas with a color or pattern.

Brush and Pencil

Select the tool, pick a brush, and set the tool options as you like. Then, click and drag over your image to paint or draw with the foreground color.

Art History Brush

The Art History Brush adds a stylized effect to your image. With this tool, your foreground color won't matter; it draws its colors from your image. The more times you pass the brush over an area (or the longer you leave it over an area) the more distorted it will become. Change the Style setting to adjust the look of the brush strokes.

Eraser

Erasing the background layer removes data to let the background color show through. Erasing an overlying layer lets the underlying layer show through.

Sponge

The Sponge tool has two modes in the Options bar: Saturate (increase the color

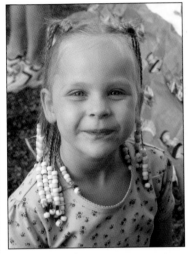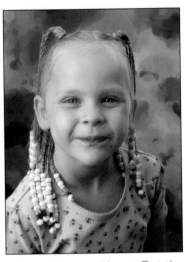

The background was selected (ensuring the painting would not affect the subject) and the Art History Brush was used to distort it.

intensity) and Desaturate (decrease the color intensity). To use this tool, select the option you want, then move your brush over the image and "paint" the change over the desired area.

Fill

To fill an area with a color, go to Edit> Fill. If you have an active selection, it will be filled; if not, the whole image area will be filled. From the bottom of the Fill dialog box, you can select the fill mode and opacity. From the Contents menu, you can choose to fill with the foreground color, the background color, black, white, 50-percent gray, or even a pattern.

The Fill dialog box.

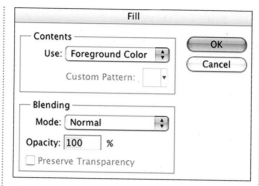

Patterns

To fill with a pattern, go to Edit>Fill, select Pattern from the Contents menu, and click the Custom Pattern thumbnail to view the existing patterns. To create a custom pattern, close the Fill box and select an area of your image with the Marquee tool (make sure Feather is set to 0 in the Options bar). Then, go to Edit>Define Pattern. In the dialog box that appears, name your pattern and hit OK. When you return to the Custom Pattern thumbnail in the Fill dialog box, the new pattern will be listed.

Paint Bucket

The Paint Bucket is like a combination of the Magic Wand and Fill command. Just set the Tolerance in the Options bar (see page 94) and click on the area you want to fill. All areas of the same color will be filled with the foreground color.

Gradient Tool

The Gradient tool lets you fill an area with a blend of two or more colors (see the middle leaf on page 100 for an example). To use it, select the Gradient tool, then click and drag over your image and release the mouse button.

In the Options bar, you can determine the style of the gradient and the colors used in it. Pull down on the arrow to the right of the colored window showing the currently selected gradient to reveal Photoshop's preset gradients. If you like, you can select one of these by clicking on it.

If you'd prefer to create your own gradient, click once on the window showing the current gradient. This will open the Gradient Editor dialog box (left). Experiment with these settings and you'll quickly see how they work.

To the right on the Options bar are boxes that allow you to select the gradient pattern (Linear, Radial, Angle, Reflected, or Diamond). At the far right are settings for Reverse (flips the colors from left to right), Dither (reduces the appearance of stripes in the gradient), and Transparency (enables any transparency edited into the gradient in the Gradient Editor dialog box).

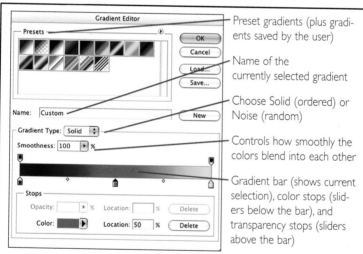

Preset gradients (plus gradients saved by the user)

Name of the currently selected gradient

Choose Solid (ordered) or Noise (random)

Controls how smoothly the colors blend into each other

Gradient bar (shows current selection), color stops (sliders below the bar), and transparency stops (sliders above the bar)

Opacity stops—To add a stop, click above the gradient bar, then drag the stop into position. To edit the opacity in the area under a stop, click on the stop to activate it (turning the point black). Then enter the percentage of opacity in the Opacity box (under Stops).
Color stops—To add a stop, click below the gradient bar, then drag the stop into position. To edit the color of the gradient in the area above a stop, click on the stop to activate it (turning the point black). Then, under Stops, use the pull-down menu to the right of the color box to select the foreground or background color. Or, click on the color box itself to activate the Color Picker, and select a color.

TEXT

Using the Type tool, you can add lettering in almost any imaginable shape or form to your images. So, the next time you want to make an invitation or flyer, consider using Photoshop for a creative look.

To add text to an image, select the Type tool from the Toolbox, then set the options as you like. Click anywhere on your image and a blinking cursor will appear. From here, begin typing your text. When you have finished, click the "⊘" (at the far right of the Options bar) to cancel your work or the "✓" button to accept it. Selecting a new tool will automatically accept the current text. All text is automatically created on a new layer.

Options

Just as you would in a word-processing program, you have a number of options for fine-tuning your text. Accessed via the Options bar, these are (left to right):

Font Family—Select the style of type (font) you wish to use from those installed on your computer.

Font Style—Choose regular, bold, italic, or another style (the styles available vary from font to font).

Font Size—Select a size from the pulldown list or type in your own value.

Anti-Alias—Smoothes the curves in the letters, preventing a jagged look.

Paragraph Justification—Controls how the lines in a paragraph are aligned (left, centered, or right).

1 The Text tool was selected and text was added to the image.

2 Using the Move tool, the text was dragged into position.

3 Two styles were added to the image, but these didn't seem right and were undone using the History palette.

4 The text was selected by clicking and dragging over it with the Text tool. The Text Warp was applied.

5 For the final image, the arched shape was retained and an Style was applied to add rainbow colors.

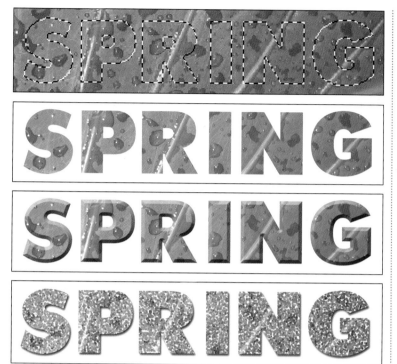

In the top image, the word SPRING was selected using the Type Mask tool. The selected area was then copied (Edit>Copy) and pasted (Edit>Paste) into a new file (second image). It could also have been pasted into a new layer in the original leaf image or into another photo. From there, it can be customized as you would any other image layer. In the third image, a bevel was added from the Effects palette. In the final image, the Pointillize filter (Filter>Pixelate>Pointillize) was applied and a drop shadow was added.

CUSTOM SHAPES

Photoshop offers a vast array of interesting custom shapes that you can add to your images—there are frames, animals, arrows, symbols, foods, and much more. To add a custom shape to your image, select the Custom Shape tool. In the Options bar, click on the Shape menu (seen above) and pick a shape. (To see all of the available shapes, click on the arrow at the top right of this menu and select All.) Choose the shape you want to use, then click and drag over your image. The shape will appear with a style applied.

Text Color—Sets the color of the text. Click on this box to activate the Color Picker (see pages 100–101).

Text Warp—Allows you to create curved and otherwise distorted text. Simply select the style of warp you want, then set it to vertical or horizontal. By adjusting the bend and horizontal/vertical distortion, you can set the warp as you like.

Paragraph and Character Palettes—These palettes duplicate some of the settings found in the Options bar but add to them some advanced settings for controlling type, like adjusting the space between letters.

Editing Text

To edit your text, select the Text tool and click on the text in your image to reactivate the cursor. You can select strings of text by clicking and dragging over the letters. You can also cut/copy and paste text by selecting it and going to Edit>Cut/Copy and Edit>Paste.

Text Styles

To add some interesting effects to your text, check out the effects in the Styles palette (see pages 82–83).

Type Mask Tool

Sometimes the effect you want to create with type is better accomplished with the text as a selection rather than as editable text. To do this, go to the Toolbox and click and hold the Text tool icon. Then choose one of the Text as Mask tools and type your text on the layer where you want the selection to be active. An example of this is shown at the top left of this page.

Basic Image Retouching

Image retouching used to be something only professionals could do, but with digital imaging, everyone has the same tools at their fingertips. With some practice, you can achieve the same flawless results!

BLEMISHES, RED-EYE

Red-eye is just one of those things we used to live with in a lot of images—but no more. Now you can quickly remove this annoyance and other little blemishes, too.

Professional image retouching can make a portrait subject look like a million bucks. Now the same tools pros use are at your fingertips, so you never have to live with blemishes and other little problems—even in your snapshots!

Clone Stamp Tool

The Clone Stamp tool works just like a rubber stamp, but the "ink" for the stamp is data from one good area of your image that you "stamp" over a problem area. Using this tool definitely takes some practice, but once you master it, you'll probably find you use it on just about every image.

To begin, choose the Clone Stamp tool from the Toolbox. Then, set the brush size in the Options bar (the size you choose will depend on the area

The Clone Stamp tool is perfect for removing small blemishes (left) and creating a more flawless look (right). You can even remove stray hairs and shape the eyebrows! Original image by Jeff Smith.

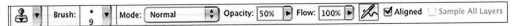

The Clone Stamp tool Options bar.

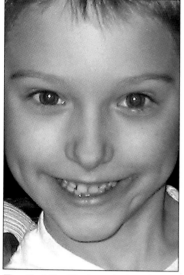

The Red Eye Tool can be used to remove red-eye (left) and create a much more pleasing appearance (right).

The Patch tool can be used to remove small distractions (left). In this portrait, it makes the background look a lot better (right).

available to sample from and the area you want to cover). Move your mouse over the area that you want to clone, then hold down the Opt/Alt key and click. Next, move your mouse over the area where you want the cloned data to appear and click (or click and drag). As with the other painting tools, you can also adjust the mode and opacity of the Clone Stamp tool in the Options bar. Don't forget to use the Zoom tool to enlarge your view for precise work.

Healing Brush, Spot Healing

The Healing Brush works just like the Clone Stamp tool, but it tries to more accurately blend the cloned material with the problem area it is stamped over.

The Spot Healing Brush works the same way, except it saves you one step: you just click on the bad area, and Photoshop will automatically determine the area that should be sampled and cloned to correct the problem.

Both of these tools work very well and can save you lots of retouching time. Watch out for problems, though, when applying these tools in areas where the original image has sharp contrasts in color or tone—where a dark silhouette meets a bright white sky, for instance. This can often cause problems with the blending.

Patch Tool

With the Patch tool active, use your cursor to draw a line around the problem area in your image. Then, release your mouse and click in the center of the selected area. By dragging, you can apply better data from another similar area of your image to the problem area. It will be blended automatically.

Red Eye Tool

Red-eye is just a fact of the anatomy of our eyes, but that doesn't mean we have to live with it in our images. Just position the Red Eye tool's crosshairs over the center of the pupil and click. If the applied color extends too far (encroaching on the iris), reduce the Pupil Size in the Options palette. If the effect is too dark or removes too much detail, reduce the Darken Amount setting.

SHARPEN OR SOFTEN

As you work toward perfecting your photos, don't neglect the impact that focus (or a little lack thereof) can have on them. Sharpening and softening are invaluable tools for fine-tuning your images.

Sharpening and blurring are everyday operations with digital images. You can use them to improve flaws in an image or to enhance the appearance of your subject.

Sharpening

If your image looks pretty much okay to the naked eye, but a little fuzziness is apparent when you really get critical, sharpening may do the trick. To sharpen an image, go to Filter>Sharpen and select the tool you want.

The Sharpen filter automatically applies itself to every pixel in the image or selection. It works by enhancing the contrast between adjoining pixels, creating the appearance of sharper focus. The Sharpen More filter does the same thing, but with more intensity.

The Sharpen Edges filter seeks out the edges of objects and enhances those areas to create the illusion of increased sharpness. Photoshop identifies edges by looking for differences in color and contrast between adjacent pixels.

Unsharp Mask is the most commonly used sharpening filter in Photoshop. To begin, go to Filter>Sharpen>Unsharp Mask. This will bring up a dialog box in which you can adjust the Amount (how much sharpening will occur), the Radius (how far from each pixel the effect is applied), and the Threshold (how similar in value the pixels must be to be sharpened). To start, try setting the Amount to 180 percent, the Radius to about 1 pixel, and the Threshold to 5 to 10 levels.

The original image was an action shot. Since the focus wasn't quite perfect, it needed some sharpening.

Using the Unsharp Mask, the image was slightly sharpened.

Sharpening must be done in moderation. Oversharpened photos look grainy and have unattractive light halos around dark areas, and dark halos around light ones.

The Unsharp Mask dialog box.

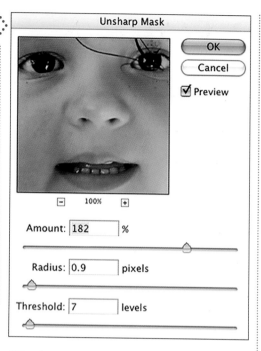

Watch the preview and fine-tune these settings until you like the results.

A recent addition to Photoshop, the Smart Sharpen filter can be set to the advanced mode to allow you to adjust your sharpening independently in the highlights and shadows. It also offers a tool for reducing motion blur.

Photoshop also has a Sharpen tool. This is used to "paint on" sharpness in selected areas and works pretty much like the other painting tools. The Select field in the Options bar is used to set the intensity of the sharpening effect.

Watch out for oversharpening. If you're not sure you've sharpened an image correctly, go to Edit>Step Backward and compare the new version to the original. If the new one *was* better, use Edit>Step Forward to return to it.

Blur

Images from digital cameras are often so sharp that they don't make people look their best. To add a forgiving amount of softness, duplicate the background layer and apply the Gaussian Blur filter to it (Filter>Blur>Gaussian Blur) at a low setting (3–5 pixels). After applying the filter, set the mode of the duplicated layer to Lighten (at the top of the Layers palette).

If some critical areas, like the eyes, seem too soft, use the Eraser tool on these areas of the *overlaying* layer to reveal the sharp data on the layer below.

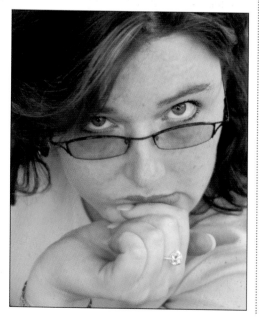

To give a softer look to the original image (right), the background layer was duplicated, blurred, and set to lighten (far right). Parts of the blurred layer were then erased to keep the eyes sharp.

DODGE AND BURN

The Dodge and Burn tools simulate classic darkroom techniques that go by the same names. Essentially, dodging lightens and burning darkens—giving you excellent control over the tones in your images.

Ansel Adams was a master in the photographic darkroom, and two of the most important techniques he used are simulated by these tools. While mastering the same tools may not instantly make you a legendary photographer, it will definitely help you make the most of all of your images.

Dodging

The Dodge tool is used to lighten areas of a print. To use it, select the Dodge tool from the Toolbox, then choose a brush (a soft brush works best). Click (or click and drag) over your image to dodge (lighten) as needed.

In the Options bar, increasing the Exposure setting will increase the amount of lightening you achieve. In the Range setting, you can specify whether you want to lighten the shadows, midtones, or highlights in a given area.

This is an important decision, so study the area you are working on carefully to determine the best approach. Often, the best selection is counterintuitive. For example, imagine you have a photograph with a dark shadow area. The area is not solid black but has very dark gray details. To bring out the details, it might seem logical to dodge the

Original photograph.

Photograph with 20-percent exposure dodge on midtones.

Dodge tool options.

shadows. However, in this case, dodging the shadow areas would mean lightening the black areas—making them gray.

If the shadow area and its details are both rendered as gray, then the contrast between them will actually be

reduced—making the details even less visible. Instead, you would want to dodge the midtones, lightening the areas that were originally *dark gray*. Making those gray areas a little lighter will make them more apparent to the viewer.

Burning

The Burn tool is used to darken areas of a print. To use it, select the Burn tool from the Toolbox, then choose a brush (a soft brush works best). Click (or click and drag) over your image to burn (darken) as needed.

In the Options bar, increasing the Exposure setting will increase the amount of darkening you achieve. In the Range setting, you can choose to darken the shadows, midtones, or highlights in a given area.

Again, this is an important decision, so carefully study the area you are working on to determine the best choice. Keep in mind, the best selection may be counterintuitive. For example, imagine you have a photograph with a bright highlight area. The area is not solid white but has very light gray details. To bring out the details, it seems it would be logical to burn the highlights. However, in this case, burning the highlight areas would mean darkening the white areas—making them light gray.

If the highlight area and its details are *both* light gray, the contrast between them has actually been reduced and the details will be even less visible. Instead, you would want to burn the midtones or shadows to make the areas that were originally light gray become somewhat darker. This will make them more apparent to the viewer of the image.

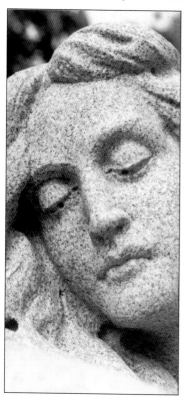

Original photograph.

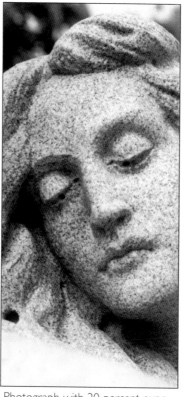

Photograph with 20-percent exposure burn on midtones.

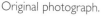

Burn tool options.

TIPS FOR DODGING AND BURNING

Neither dodging nor burning can add detail that isn't in the original image. These tools are most useful for making small changes, such as lightening up a shaded area that's just a little too dark, or making an area that is too light just a little less bright and distracting. You'll rarely get good results dodging a solid black (or extremely dark) area or a solid white (or extremely light) area.

Simple Photo Projects

Now that you've learned the basic tools and commands in Photoshop, you can move on to begin combining these techniques to create your own unique digital works of art.

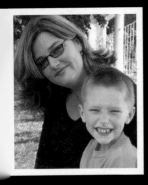

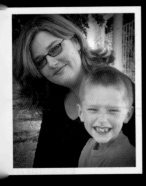

HANDCOLORING

Handcoloring is an incredibly versatile way to really personalize your images—and the effects can be as subtle or dramatic as you want.

Handcoloring photos is traditionally accomplished with a variety of artistic media—oil paints, pencils, etc. With Photoshop, you can create this classic look much more easily.

Method 1

This technique gives you total control over the colors you add and where you add them.

First, open an image. If it's a color image, go to Image>Adjustments>Desaturate to create a black & white image. If it's a black & white image already, make sure it's in the RGB mode (see page 8). Then, create a new layer and set it to the Color mode (see page 86–87).

Double click on the foreground color swatch to activate the Color Picker. Select the color you want and hit OK to select it as the new foreground color. This is the color your painting tools will apply. You may switch it as often as you like.

With your color selected, return to the new layer you created in your image. Click on this layer in the Layers palette to activate it, and make sure that it is set to the Color mode.

Select the Brush tool and whatever size/hardness brush you like, and begin painting. Because you have set the layer

Several colors were applied to this black & white image to create a handcolored look.

mode to Color, the color you apply with the brush will allow the detail of the underlying photo to show through.

If you're a little sloppy, use the Eraser tool (set to 100 percent in the Options bar) to remove the color from anywhere you didn't mean to put it. Using the Zoom tool to move in tight on these areas will help you work as precisely as possible.

If you want to add more than one color, you may wish to use more than one layer, all set to the Color mode.

When you've completed the "handcoloring," your image may be either completely or partially colored. With

FOR BETTER PAINTING

It can be pretty tricky to paint on an image using your mouse. For better, more precise control, consider investing in a graphics tablet. Alternately, you can use selections to help you stay inside the lines with your painting.

everything done, you can flatten the image and save it as you like.

Method 2

Here's a quick way to add a hand-colored look in seconds—or, with a little refinement, to avoid having to select colors to handcolor with. This technique works only with a color image.

Begin by duplicating the background layer (by dragging it onto the duplication icon at the bottom of the Layers palette).

Next, remove the color from the background copy by going to Image>

Adjustments>Desaturate. The image will turn black & white—but by reducing the opacity of the new layer you can allow the colors from the underlying photo to show through as much or as little as you like. Try setting the layer opacity to 80 percent for a subtly colored image.

To create the look of a more traditional black & white handcolored photograph, set the opacity of the desaturated layer to 100 percent and use the Eraser tool to reveal the underlying photo. Adjust the Eraser's opacity to allow as much color to show through as you like.

For a very soft look, set the opacity of the desaturated layer to about 90 percent (just enough to let colors show through faintly) and use the Eraser tool (set to about 50 percent) to erase areas where you want an accent of stronger color to appear.

The background layer was duplicated and the color removed. Then its opacity was set to 90 percent, allowing a little color to show through. The area over the body of the guitar was erased completely, allowing the underlying color image to show through.

RESTORING AN IMAGE

Very few images can be fixed with only one tool.
In most cases, you'll need to employ several tools, combining
their functions to make the needed corrections and enhancements.

The first step when restoring an image is to make a quick visual analysis and create a to-do list of things to fix. For this image, the list included the following points:

1. There were several spots and specks on the photo—as well as a few areas where the surface had torn away.
2. The photo was faded and yellowed. It had also lost some contrast.
3. The blue ink had also faded, making the inscription difficult to read.

The first step was to correct the damaged areas and the spots and specks. Since these were small and scattered across the photograph, the Clone Stamp tool was used to sample nearby data and copy it over the damaged areas.

The next step in the restoration of this photograph was to remove the yellow color cast. This could have been accomplished using a number of different tools (Auto Color, Variations, etc.).

Damaged area before correction.

Original image.

Area after correction with the Clone tool.

rojects

The original image
(left). The image
after removing the
yellow color cast
with the Color Cast
Correction command
(center). The image
after contrast correc-
tion with the Levels
(right).

For this black & white image, the easiest way to remove the color cast was to use the Set Gray Point eyedropper in the Levels (see pages 58–59). The Levels were then used to adjust the contrast (see pages 52–53).

The inscription had become a little faded. This was enhanced in two ways. First, the Hue/Saturation command was used to increase saturation of the blue tones. This worked well since it was the only blue in the image. To fill the gaps in the ink, the Brush tool was selected. Using the Eyedropper tool, the ink color was set as the foreground color. The brush size (after a couple of tries) was matched as closely as possible to the width of the ink line, and the hardness was set to about 70 percent to create relatively sharp edges.

Next, a new layer was created and activated in the Layers palette. After zooming in tight on the inscription (using the Zoom tool), the letters were traced with the Brush tool set to 50-percent opacity. Special attention was paid to areas where gaps occurred in the original writing.

When complete, the layer was set to the Multiply layer mode, making the painted areas on the layer blend in well with the original ink underneath. This also darkened the combination slightly, for easier reading.

Before enhancement. After enhancement.

Final image.

COMPOSITING IMAGES

Combining two images into one in a realistic way (called compositing) is extremely difficult with traditional photographic techniques—but Photoshop offers the controls you need to accomplish it seamlessly.

Originally, one of the most interesting uses for digital imaging was to combine elements of two images in a realistic way. While it's no longer a *primary* reason to use digital, compositing can still be a fun exercise.

The criteria for selecting images to composite should be rigorous. For realistic results, the direction and quality of lighting should be very similar in both photos—an image taken with bright sunlight coming from the left won't look realistic when combined with a shot taken under soft light from the right, for example. It also helps if all of the elements are well exposed and have no big color problems. You should also check to make sure the focus is correct; a softly focused subject on a sharply focused background won't look realistic.

This project began with two images—one of train tracks (left) and one of a biker doing an aerial trick (top right). The first step in combining the shots was to remove the background from the biker shot (bottom right).

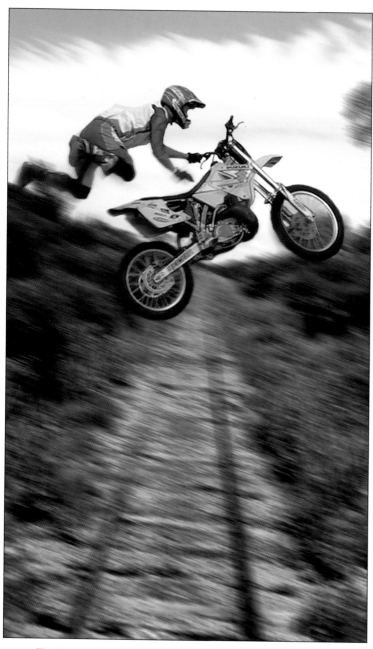

The final image.

selection was then feathered two pixels (Select>Feather) to soften the edges and make them less obvious when moving the subject into the train-tracks image. The selected area was copied (Edit> Copy) and pasted (Edit>Paste) into a new layer in the background image.

Since this composite was intended to look realistic, correct positioning and scaling of the new element on the background was the next task. To do this accurately, look at the size of the imported material. Does it need to be changed in order to make sense with the subjects around it? If so, go to Edit>Transform> Scale and make any needed adjustments. (*Note:* If you're creating a fantastical or abstract composite, you can use this same technique to make the imported subject look wildly out of scale with the background.) Once the subject was scaled, the Move tool was used to position him over the tracks.

Next, look at the color and brightness of the new element in relation to the background image. Correct any problems by using the color correction tools covered in chapters 4 and 5.

For this image, the final step was to add some motion blur, creating the impression that the camera panned with the biker as he made this very impressive leap. To do this, the image was flattened (Layer>Flatten Image) and the background layer was duplicated (Layer> Duplicate Layer). The Motion Blur filter (Filter>Blur>Motion Blur) was applied on the duplicated layer. Finally, the Eraser tool was used to restore sharpness as needed (on the bike and biker).

When done, flatten your image and wow your friends with the results!

Look at the images carefully and decide which contains more of the material you want in the final image. In this case, the train tracks will be the background for the final image. The only part of the other photograph that will be used is the biker.

Therefore, the biker was selected using the Lasso and Magic Wand tools, isolating him from the background. The

WEB AND PRINT GRAPHICS

Want to design digital scrapbook pages for your family album or create a must-see web site? Here are some ideas for visually appealing effects that will add a professional polish to your project.

Using Photoshop isn't just about making photos look better—it's also great for creating graphics. Whether or not these graphics include photos at all is up to you.

Plan for Output

Before you put a lot of work into creating a graphic, do take the time to make sure you are creating it at the right size and resolution. A little planning will save you a lot of frustration.

Design Basics

With Photoshop, you have complete control over the colors, size, and placement of the elements in your graphics. Take advantage of this and don't settle for just "okay." If you don't have much experience with graphic design, consider picking up a book for beginners (*The Non-Designer's Design Book* by Robin Williams [Peachpit Press, 1994] is a great one). You'll be surprised how a few simple changes to a design can make it suddenly spring to life.

Buttons and Banners

If you're creating a web site, why settle for simple text links when you can create a stylish button instead? Once you've created your button, consult your web-

design software for how to put it in your page and define it as a link. Don't limit yourself to using effects like these on your web site, though—snazzy buttons and banners can work great in lots of other design projects too.

The buttons shown below were all created in Photoshop by opening a new document with a white background, then creating a new layer. On the layer, the desired shape of the button was selected (using one or more of the selection tools or the Custom Shape tool). Each selection was then filled with a solid color or gradient, and effects from

There are limitless options for creating buttons in Photoshop. A few ideas are shown to the left—but you can also try making buttons out of photos, adding text to buttons, and much more!

Banners and rules normally run horizontally to help divide sections in a design, but they can also be used vertically to set off important information from other text or images.

the Styles palette were applied to create a wide variety of results.

Banners containing text and rules normally stretch across a page and help to divide sections of the page so viewers can navigate more easily. They can be created in the same way as buttons—you just choose a different shape.

Background Photos

Very light, low-contrast images (often in black & white or toned in another color) make great backgrounds for text or other images. The rule of thumb:

make the image as light as you can stand it, then make it a little lighter. The image must be truly subtle—especially when you want to use text over it.

An easy way to achieve this effect is to open the Hue/Saturation dialog box (see page 40). Click the Colorize box and adjust the Hue slider to render the image in a single color. Then, set the lightness very high (for the image below, it was set to 80).

Background Patterns

Abstract images are another popular background choice. There are countless ways to make them in Photoshop. Running multiple filters (or the same one many times) can produce some very interesting looks. The Wave filter works particularly well for turning photos into unrecognizable patterns. You can also use the painting tools to create shapes and colors, then blur them or distort them in other ways that make them look more interesting. In fact, that's how the blue pattern at the top of this page was created.

Very light, low-contrast images make great backgrounds for web pages and other designs. Here, a photo of a field of flowers was used as the background for a community garden's web site. The overlying photos have drop shadows applied to their layers, and blue buttons were used to highlight the links.

PANORAMIC IMAGES

Creative types have been combining photos since the beginning of photography—but doing it digitally certainly works a lot better than the old scissors-and-glue method!

Panoramic images are created digitally by shooting a sequence of images and then combining them into one photograph.

Shooting the Images

When you decide to make a panoramic image you'll need to plan to do so *before* you start shooting. First, select a mid-range lens (or if you are using a point-and-shoot with a zoom lens, set it about halfway out). It might seem like a good idea to use a wide-angle lens, but this will cause distortion at the edges of the images, making them nearly impossible to join together seamlessly.

Next, select one exposure setting and focus setting and stick to it. The idea is to create the look of a single image, and that won't happen if some sections are lighter/darker than others, or if the focus suddenly shifts.

It's also important to maintain a consistent camera height (for best results, use a tripod).

Let's imagine you are standing facing the part of the scene that you want to have on the left edge of your final panoramic. Lift the camera and take the first shot, noting what is on the right-hand edge of the frame. Pivot slightly to the right and place the subject matter

To create a seamless panoramic image, try shooting from a tripod. For this image, the subject was repositioned for each shot so he shows up numerous times in the final photograph.

In the first Photomerge dialog box, click Browse to select the images you want to merge.

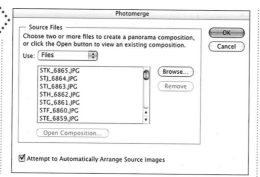

In the second Photomerge box, make sure all the images are positioned correctly, then hit OK.

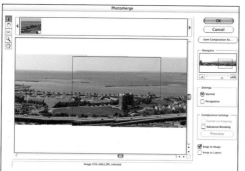

that was in the right-hand part of the first frame just inside the left edge of the second photo. Continue until you've covered the desired area.

If you're shooting digitally, see if your camera has a panoramic setting. If so, switching to it will usually change the display on the LCD screen so that

you can see the image you are about to shoot and the previous one side by side.

Photomerge

Combining images is relatively simple. When you go to File>Automate>Photomerge the first dialog box will open. Click Browse and select the images to merge. When all of the files appear in the Source Files window, hit OK.

In the next dialog box, Photoshop will try to place the photos in the correct position. If it can't, the photos it can't place will appear as thumbnails at the top of the window. You can then drag them down into the main window and position them yourself. You can also click and drag the other images in the main window to reposition them if Photoshop doesn't do it correctly. When everything is in position, hit OK.

When the final image appears, it will usually have some uneven edges where the original photos overlap. Cropping the image will eliminate this and create the impression of a single image.

Outputting Images

Making prints is still how most people tend to share their important photos, so make sure yours look great. For easy image sharing don't forget to consider online methods—you might even want to set up your own photography web site.

IMAGES IN ACTION

You've spent hours (or maybe just seconds) making the perfect image, so now what? It's time to share your creative genius with the world!

What's the point in creating a great image if you don't display it well? It is important to make sure your images look their best as you show them off, whether in prints on online.

Image Prep

Before outputting, flatten any layers you have created. Then, save the image in the required file format (usually JPEG or TIFF). Finally, double-check the size and resolution of your image.

Inkjet Printing

If you'll be printing your image on your inkjet printer, check the manual for the resolution it recommends. For the best results, take the time to read about the printer's software and the options it gives you for setting printing specifications. If it allows you to select the type of paper you will be printing on, be sure to select the one that best matches your paper—and do be sure to try printing on digital photo paper. It can be a little on the pricey side, but the results you'll get will far exceed what you can achieve on plain paper.

Lab Printing

Lab printing is really a win–win situation. The prints are real photographs

CONTACT SHEETS

When you get a digital camera and start working on your photographs digitally, you'll probably take and work with more images than you ever did with film—and why not, since they're basically free! This sheer volume of images can, however, make it something of a challenge to find a particular image when you want it. To make this easier, it can be very useful to create contact sheets (File>Automate>Contact Sheet II). This lets you print lots of small images on one page and automatically puts the name of the file under each one. As you archive your work to CD-R or DVD-R, you may want to make a contact sheet for each disc and store it with the disc. When you do, you'll be able to find photos in a snap.

(made on the same machine that is used to print your images from negatives) so they look great and will last for years and years, unlike inkjet prints. Also, with even corner drugstores offering digital prints for about $.20, they actually cost less than printing at home. For online photo labs (like www.Snapfish.com and

www.Shutterfly.com), you will normally save your files as JPEGs and upload the images directly to the web site. To use a lab in your area, save your files as JPEGs on CD (or on a digital memory card) and just take them to the lab.

Picture Packages

The Picture Package (File>Automate>Picture Package) function in Photoshop lets you print multiple copies of one image in an aassortment of sizes on one page. For home printing, this is especially efficient, since it allows you to make the most of each sheet you print. For lab printing, it may actually be more cost-effective to print a few smaller images individually. The exception can be with wallet-size prints, which sometimes command a premium price. Instead of paying this, you can create an 8x10-inch page with sixteen wallet-size images and

print it just like any other 8x10-inch image.

Slide Shows

To create a slide show, go to File>Automate>PDF Presentation. Under Output Options, click Presentation. From the dialog box, select the images for your slide show, how long each remains on-screen, and how to transition between them, then hit OK. To view the slide show, use Adobe Acrobat. This may already be on your computer, or you can download it for free at www.adobe.com.

Web Photo Gallery

Creating a Web Photo Gallery lets you automate the creation of a web page to display your photographs. To start, move the photos you want on your page to one folder. Then, go to File>Automate>Web Photo Gallery and choose a style from the pull-down menu (there are lots of looks to choose from). Enter your e-mail address if you want it to appear on the page, then (under Folders) select the folder of images for your page and a place to save the page (Destination).

The settings in the Options section at the bottom of the box vary with the style you choose. They let you add a banner (text that appears at the top of the gallery), control the fonts and colors used, adjust the size of the thumbnails and images in the gallery, and more.

When you've completed your web photo gallery, you can view it on your computer or upload it to your web site. Since all Internet service providers work a little differently, consult yours for specific information on how to do this.

In the Picture Package dialog box, choose Frontmost Document to work with a file you already have open, or set the Use menu to File and click Choose to select another image. Under Document, select the desired page size, layout, and resolution. You can label your photos using the controls at the bottom of the box.

INDEX

OTHER BOOKS FROM

Amherst Media®

Also by the Same Author . .

COLOR CORRECTION AND ENHANCEMENT WITH ADOBE® PHOTOSHOP®

Master precision color correction and artistic color enhancement techniques for scanned and digital photos. $29.95 list, 8½x11, 128p, 300 color images, index, order no. 1776.

BEGINNER'S GUIDE TO ADOBE® PHOTOSHOP® ELEMENTS®

Packed with easy lessons for improving virtually every aspect of your images—from color balance, to creative effects, and more. $29.95 list, 8½x11, 128p, 300 color images, index, order no. 1790.

THE PRACTICAL GUIDE TO DIGITAL IMAGING

This book takes the mystery (and intimidation!) out of digital imaging. Short, simple lessons make it easy to master all the terms and techniques. $29.95 list, 8½x11, 128p, 150 color images, index, order no. 1799.

DIGITAL PHOTOGRAPHY 101

Skip all the jargon and get started quickly with this no-nonsense guide to digital photography! Covers everything you *must* know to succeed—from selecting equipment, to shooting, enhancing, printing, and archiving your images. Perfect for new digital camera owners! $14.95 list, 6x9, 96p, 110 color photos, index, order no. 1903.

DIGITAL CAMERA TRICKS AND SPECIAL EFFECTS 101

With a digital camera and basic image-editing software, creating eye-popping special effects is amazingly easy! These step-by-step lessons get you started quickly. $14.95 list, 6x9, 96p, 120 color images, index, order no. 1906.

OUTDOOR AND LOCATION PORTRAIT PHOTOGRAPHY, 2nd Ed.

Jeff Smith

Learn to work with natural light, select locations, and make clients look their best. Packed with step-by-step discussions and illustrations to help you shoot like a pro! $29.95 list, 8½x11, 128p, 80 color photos, index, order no. 1632.

WEDDING PHOTOGRAPHY

CREATIVE TECHNIQUES FOR LIGHTING, POSING, AND MARKETING, 3rd Ed.

Rick Ferro

Creative techniques for lighting and posing wedding portraits that will set your work apart from the competition. Covers every phase of wedding photography. $29.95 list, 8½x11, 128p, 125 color photos, index, order no. 1649.

STUDIO PORTRAIT PHOTOGRAPHY OF CHILDREN AND BABIES, 2nd Ed.

Marilyn Sholin

Work with the youngest portrait clients to create cherished images. Includes techniques for working with kids at every developmental stage. $29.95 list, 8½x11, 128p, 90 color photos, order no. 1657.

CORRECTIVE LIGHTING, POSING & RETOUCHING FOR

DIGITAL PORTRAIT PHOTOGRAPHERS, 2nd Ed.

Jeff Smith

Learn to make every client look his or her best by using lighting and posing to conceal real or imagined flaws—from baldness, to acne, to figure flaws. $34.95 list, 8½x11, 120p, 150 color photos, order no. 1711.

PORTRAIT PHOTOGRAPHER'S HANDBOOK, 2nd Ed.

Bill Hurter

Bill Hurter has compiled a step-by-step guide to portraiture that easily leads the reader through all phases of portrait photography. This book will be an asset to experienced photographers and beginners alike. $29.95 list, 8½x11, 128p, 175 color photos, order no. 1708.

ARTISTIC TECHNIQUES WITH ADOBE® PHOTOSHOP® AND COREL® PAINTER®

Deborah Lynn Ferro

Flex your creative skills and learn how to transform photographs into fine-art masterpieces. Step-by-step techniques make it easy! $34.95 list, 8½x11, 128p, 200 color images, index, order no. 1806.

MASTER GUIDE FOR
UNDERWATER DIGITAL PHOTOGRAPHY

Jack and Sue Drafahl

Make the most of digital! Jack and Sue Drafahl take you from equipment selection to underwater shooting techniques. $34.95 list, 8½x11, 128p, 250 color images, index, order no. 1807.

DIGITAL PHOTOGRAPHY BOOT CAMP

Kevin Kubota

Kevin Kubota's popular workshop is now a book! A down-and-dirty, step-by-step course in building a professional photography workflow and creating digital images that sell! $34.95 list, 8½x11, 128p, 250 color images, index, order no. 1809.

BLACK & WHITE PHOTOGRAPHY

TECHNIQUES WITH ADOBE® PHOTOSHOP®

Maurice Hamilton

Become a master of the black & white digital darkroom! Covers all the skills required to perfect your black & white images and produce dazzling fine-art prints. $34.95 list, 8½x11, 128p, 150 color/b&w images, index, order no. 1813.

PROFESSIONAL MARKETING & SELLING TECHNIQUES

FOR DIGITAL WEDDING PHOTOGRAPHERS,
SECOND EDITION

Kathleen Hawkins

Taking great photos isn't enough to ensure success! Become a master marketer and salesperson with these easy techniques. $34.95 list, 8½x11, 128p, 150 color photos, index, order no. 1815.

WEDDING PHOTOGRAPHY WITH ADOBE® PHOTOSHOP®

Rick Ferro and Deborah Lynn Ferro

Get the skills you need to make your images look their best, add artistic effects, and boost your wedding photography sales with savvy marketing ideas. $29.95 list, 8½x11, 128p, 100 color images, index, order no. 1753.

WEB SITE DESIGN FOR PROFESSIONAL PHOTOGRAPHERS

Paul Rose and Jean Holland-Rose

Learn how to design, maintain, and update your own photography web site—attracting new clients and boosting your sales. $29.95 list, 8½x11, 128p, 100 color images, index, order no. 1756.

THE DIGITAL DARKROOM GUIDE WITH ADOBE® PHOTOSHOP®

Maurice Hamilton

Bring the skills and control of the photographic darkroom to your desktop with this complete manual. $29.95 list, 8½x11, 128p, 140 color images, index, order no. 1775.

DIGITAL PHOTOGRAPHY FOR CHILDREN'S AND FAMILY PORTRAITURE

Kathleen Hawkins

Discover how digital photography can boost your sales, enhance your creativity, and improve your studio's workflow. $29.95 list, 8½x11, 128p, 130 color images, index, order no. 1770.

PROFESSIONAL STRATEGIES AND TECHNIQUES FOR DIGITAL PHOTOGRAPHERS

Bob Coates

Learn how professionals—from portrait artists to commercial specialists—enhance their images with digital techniques. $29.95 list, 8½x11, 128p, 130 color photos, index, order no. 1772.

PLUG-INS FOR ADOBE® PHOTOSHOP®

A GUIDE FOR PHOTOGRAPHERS

Jack and Sue Drafahl

Supercharge your creativity and mastery over your photography with Photoshop and the tools outlined in this book. $29.95 list, 8½x11, 128p, 175 color photos, index, order no. 1781.

POWER MARKETING FOR WEDDING AND PORTRAIT PHOTOGRAPHERS

Mitche Graf

Set your business apart and create clients for life with this comprehensive guide to achieving your professional goals. $29.95 list, 8½x11, 128p, 100 color images, index, order no. 1788.

PROFITABLE PORTRAITS
THE PHOTOGRAPHER'S GUIDE TO CREATING PORTRAITS THAT SELL

Jeff Smith

Learn how to design images that are precisely tailored to your clients' tastes—portraits that will practically sell themselves! $29.95 list, 8½x11, 128p, 100 color photos, index, order no. 1797.

PROFESSIONAL TECHNIQUES FOR
BLACK & WHITE DIGITAL PHOTOGRAPHY

Patrick Rice

Digital makes it easier than ever to create black & white images. With these techniques, you'll learn to achieve dazzling results! $29.95 list, 8½x11, 128p, 100 color photos, index, order no. 1798.

DIGITAL PORTRAIT PHOTOGRAPHY OF
TEENS AND SENIORS

Patrick Rice

Learn the techniques top professionals use to shoot and sell portraits of teens and high-school seniors! Includes tips for every phase of the digital process. $34.95 list, 8½x11, 128p, 200 color photos, index, order no. 1803.

THE BEST OF PHOTOGRAPHIC LIGHTING

Bill Hurter

Top professionals reveal the secrets behind their successful strategies for studio, location, and outdoor lighting. Packed with tips for portraits, still lifes, and more. $34.95 list, 8½x11, 128p, 150 color photos, index, order no. 1808.

MARKETING & SELLING TECHNIQUES
FOR DIGITAL PORTRAIT PHOTOGRAPHERS

Kathleen Hawkins

Great portraits aren't enough to ensure the success of your business! Learn how to attract clients and boost your sales. $34.95 list, 8½x11, 128p, 150 color photos, index, order no. 1804.

PROFESSIONAL DIGITAL PHOTOGRAPHY

Dave Montizambert

From monitor calibration, to color balancing, to creating advanced artistic effects, this book provides those skilled in basic digital imaging with the techniques they need to take their photography to the next level. $29.95 list, 8½x11, 128p, 120 color photos, order no. 1739.

SUCCESS IN PORTRAIT PHOTOGRAPHY

Jeff Smith

Many photographers realize too late that camera skills alone do not ensure success. This book will teach photographers how to run savvy marketing campaigns, attract clients, and provide top-notch customer service. $29.95 list, 8½x11, 128p, 100 color photos, order no. 1748.

THE BEST OF CHILDREN'S PORTRAIT PHOTOGRAPHY

Bill Hurter

Rangefinder editor Bill Hurter draws upon the experience and work of top professional photographers, uncovering the creative and technical skills they use to create their magical portraits of these young subejcts. $29.95 list, 8½x11, 128p, 150 color photos, order no. 1752.

PROFESSIONAL TECHNIQUES FOR
DIGITAL WEDDING PHOTOGRAPHY, 2nd Ed.

Jeff Hawkins and Kathleen Hawkins

From selecting equipment, to marketing, to building a digital workflow, this book teaches how to make digital work for you. $29.95 list, 8½x11, 128p, 85 color images, order no. 1735.